DIOR

THE NEW LOOK REVOLUTION

DIOR
THE NEW LOOK REVOLUTION

Texts by Laurence Benaïm
Foreword by Florence Müller

Rizzoli
NEW YORK

New York · Paris · London · Milan

CONTENTS

II
EXPERTISE, LINE, AND STRUCTURE

I
THE *BAR* SUIT, A REVOLUTION

III
THE ESSENCE OF A STYLE, HOMAGE, AND CONTINUITY

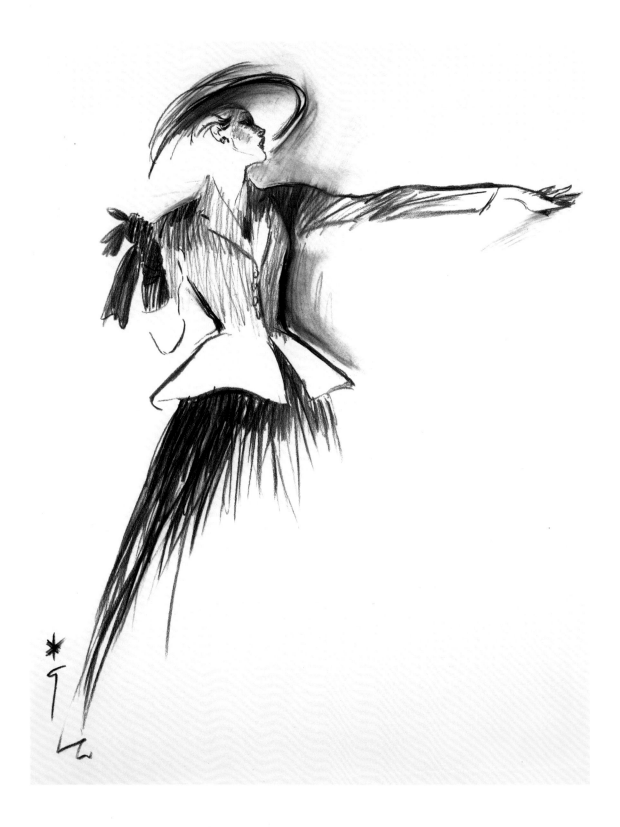

Illustration of the *Bar* suit by René Gruau, 1987.

The New Look Revolution:
"Audacity Within the Tradition of Couture"

Florence Müller
Curator of the *Dior: The New Look Revolution* exhibition

Having illustrated the links uniting Dior and the art world in recent exhibitions, for the summer of 2015 the Christian Dior Museum is presenting the New Look revolution and the exceptional place it holds in the history of fashion. This book offers an in-depth exploration of this historical event, which has far-reaching contemporary repercussions. With his first haute couture collection, launched in Paris on February 12, 1947, Christian Dior put an end to an austere and masculine style, and replaced it with a return to triumphant femininity. For a world in full reconstruction mode, the New Look evoked memories of a glorious past and imposed a new aesthetic that focused resolutely toward the future. In contrast to the cold, flat, and rectilinear silhouette of the day, Christian Dior created a fluid style that was all curves. Elevating the beauty of the feminine figure with vivid swirling lines, he celebrated its seductive power.

Among the ninety-five designs that formed this revolution in taste and style, the *Bar* suit shone as the definitive one. In a simple duo of black and ivory, free of superfluous detail, the *Bar* was created with an elaborate and imperceptible cutting process that saw outer beauty arise from inner structure. The impact of the *Bar* was truly dramatic. Its full black skirt with fluid pleats was the pedestal for a luminous ivory silk jacket that shaped the svelte figure of star model Tania, who was "femininity itself."[1] This apparition marked the beginning of the time that would come to be known as "the thirty glorious years of fashion," an era in which the "exquisite and glorious restitution of woman to herself"[2] was enthusiastically adopted. Christian Dior's successors would in turn illustrate the quest for perfection by rewriting the stylistic grammar of the house using their own sensibilities. The standard for excellence, in terms of both design and cutting technique, was handed down over the years. Then, upon his arrival in 2012, Raf Simons placed the New Look principles in a contemporary context by designing a tuxedo pantsuit that was truly architectural.

An exceptional selection of haute couture creations from 1947 to 2015, as well as photographs, documents, New Look mementos, manuscripts, original drawings, *Bar* suit miniatures, New Look dolls, patterns, and toiles, rounded out with the legendary *Miss Dior* perfume, allow the museum to establish, at the very heart of the couturier's childhood home in Granville, a veritable ancestry of the Dior style that stems from the founding impetus of the New Look. Owned by the Christian Dior Museum and the house of Dior or on loan from the Paris Museum of Decorative Arts, the Palais Galliera, and private collectors, these creations are, in the words of Christian Dior, a testament to "audacity within the tradition of couture." [3]

[1] Christian Dior, *Dior by Dior*, V&A Publishing, London, 2012, p. 129.
[2] *Elle* (French edition), March 4, 1947, p. 9.
[3] Christian Dior, *op. cit.*, p. 193.

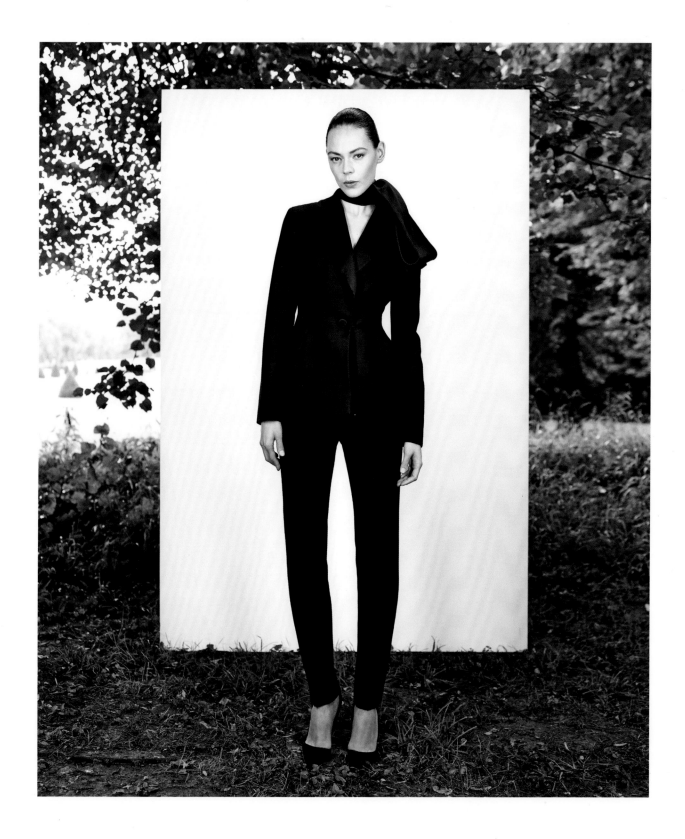

Black wool tuxedo "Bar" jacket with black wool cigarette pants,
Autumn-Winter 2012 Haute Couture collection.
Photograph by Patrick Demarchelier.

I

THE *BAR* SUIT,
A REVOLUTION

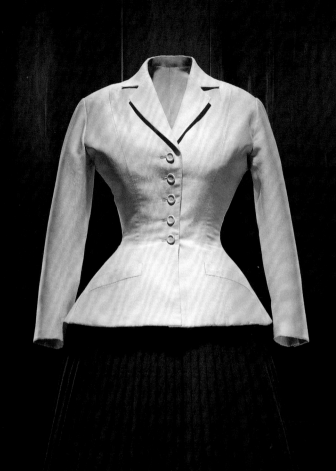

An Ideal of
Civilized Happiness

Three letters and a triumph. "*Bar*: afternoon suit, full skirt, black wool, natural shantung jacket." The name *Bar* in itself denotes an icon, a reference, and a promise of rebirth, of which Christian Dior, at the age of forty-two, was the master. "In December 1946, as a result of the war and uniforms, women still looked and dressed like Amazons. But I designed clothes for flower-like women, with rounded shoulders, full feminine busts, and hand-span waists above enormous spreading skirts."[1]

Named after the bar at the Hôtel Plaza Athénée that had opened on the eve of war in 1913 and was back in business again in 1946, the *Bar* suit was a manifesto. In spite of the ration cards that overshadowed the lives of the French until 1949, the suit signaled the symbolic arrival of a new era filled with reminiscence. It embodied a promise of renewal worthy of the "dream-making machine" evoked by René Clair[2] when describing the motion picture camera. In fact, in 1947 Christian Dior designed the costumes for the Clair film *Le Silence est d'or*, and aside from the laced up ankle boots, which were replaced by high-heeled shoes, can similarities not be seen between the white blouse of the film and the *Bar* suit jacket? Is there not a link in the shape of the hips and the emphasized derrière, in the curve of the back and the S shape, which was a promise of seduction and the signature style of 1900s Paris? In 1908, the novelist Henri Barbusse wrote, "She has finished dressing. She has put on a jacket the color of her skirt that reveals the bodice of her lingerie, the top of which is transparent and pink."[3] Reference is also made to a jacket by Redfern, a British clothier headed by John Redfern that in 1888 was officially named Dressmaker by Royal Appointment to Queen Victoria and the Princess of Wales, as well as to the empress of Russia. It is to Redfern, in 1885, that we owe the invention of the modern tailored suit.

Christian Dior was fond of references, and he loved to allude to his own story, and the very personal way in which he became totally committed to the designs that he spoke of as his daughters: "On the fresh, still unblemished page before me, I hoped to record nothing but happiness."[4] The *Bar* suit was a byword for a new take on the Belle Époque and was a founding act in rediscovering memory.

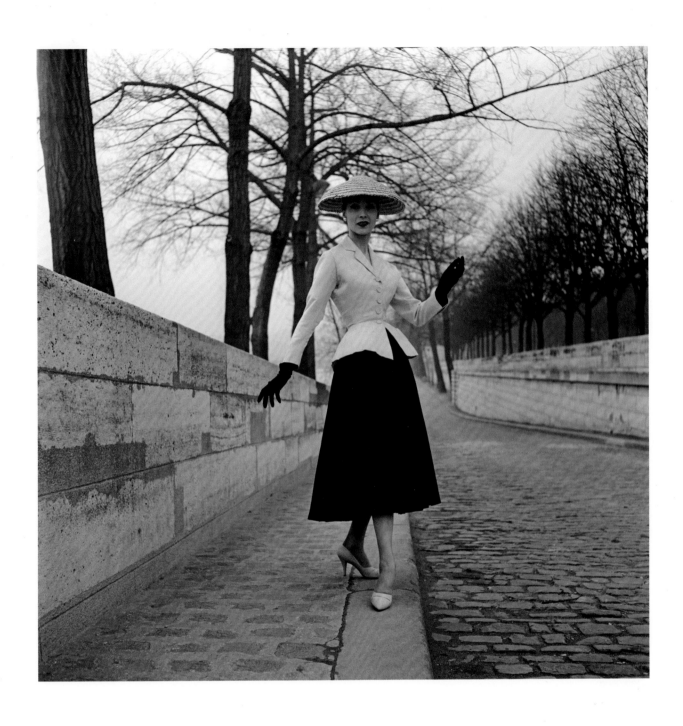

Modèle "Bali" Robe après midi

6 m tissu 90 m
0 30 soie forte
0 2/ (a Jorme
0.2/ ouate
1 Fermeture t/ 3/
1 Centure vernis

 Boutons plisseur

tissu rouge imprimé
fleur Noir

sur Paule

atelier Christiane

Modèle "Bar"

 Jaquette
3.75 Shantung
3m Drilleu
1.50 toile de laine
1.50 fal de Coton
5 Boutons.
 Jupe lainage

¼ lainage
 L'ensemble δ 50 a 140.

Veste Shantung
Jupe noire plisse
mans montée sur emp.

sur Tama

Jaq Pierre
Jupe Monique

Extract from the fabrication notes for the
Spring-Summer 1947 Haute Couture collection.

It combined recollections of youth with mastery of a French ideal inherited from the Enlightenment era, and it was as structured as a Champagne flute in a Paris whose audacity and impertinence were highlighted by Christian Dior. The name was as short as its skirt was long. It was brief, where a lengthy stream of comments poured forth, in telegrams and salons everywhere, led by that of Carmel Snow, editor of *Harper's Bazaar*, who stated, "It's quite a revolution, dear Christian, your dresses have such a new look!"

On February 12, 1947, in the fragrant salons of 30 avenue Montaigne, Christian Dior had just presented his first collection, which included *Acacias, Alma, Amour, Avril, Africaine, Auteuil, Au Bois, Aventure, Amoureuse, Athénée, Arachné, Absence, Ardoise*, and *Avenue*. The saleswomen had been there since six o'clock in the morning. Fourteen models and their dressers, along with two hairdressers, two make-up artists, and various parasols and muffs all piled into the fitting room. *Bar* was the afternoon suit presented along with *Bali* and *Boy, Bornéo, Bled, Bonheur Parfait*, and *Bon Voyage*. But what about *Bar*? It was not the most spectacular design when seen in comparison with the sheer volume of the *Bonheur Parfait* dinner dress made with thirty-six feet of navy taffeta, or the rustle of the glazed faille designs led by *Chérie*. The *Bar* suit was sold to clients for 58,500 francs, and to buyers for 65,000 francs (respectively 3,600 dollars and 4,000 dollars in 2015). Although it cost half the price of *Bonheur Parfait*, the *Bar* suit captivated passions that history would never cease to kindle and to honor.

"The *Bar* suit was one of the most in demand designs. I have to say it was the perfect embodiment of the collection. As the days passed, it became so precious and so symbolic that we ended up putting it away like a rare manuscript, like a testimony to the fashion of an era," recalls Suzanne Luling. Although the bestselling designs were, in order, *New York* (respectively thirty-seven sold to buyers and twenty-three to clients), *Maxim's, 1947, Amour, Avril*, and *Hyde Park*, the *Bar* nevertheless totaled a notable score with seven buyers and fourteen clients, much envied by those that lost out, such as *Fidélité, Bleuette, Cygne*, and *Simple*. The *Bar*, along with *Alma, Auteuil, Classique, Daisy, Pompon*, and *Rialto*, made up the seven afternoon suits presented that day. With this suit, Christian Dior reconstituted a forgotten agenda, which café society endeavored to fulfill, from theater matinees to cosmopolitan teas. The collection presented "travel," "sport," "restaurant," "street," "city," and "evening" suits. "The suit," Christian Dior would later claim, "is without a doubt the most important piece in the female wardrobe, for it is the best adapted to today's lifestyle."[5]

In 1947, in salons scented with *Miss Dior*, which was to be launched in December of the same year, two lines blossomed freely: the *En 8* line, which was "clean and curved

with an emphasized bust, cinched waist, and accentuated hips," and the *Corolle* line, which was "swirling, very voluminous, with a fitted bust and narrow waist." It was a shock. Although the *Chérie* dress had a "tight bodice, a tiny waist,"[6] the *Bar* suit was the most graphic version of this "new" fashion cherished by Christian Dior. It was with this sculpted enigma that the couturier, who had already sown the seeds of his key design at Lelong in 1946, created a look—with a stroke of black on a white page. Successive lines would follow each season, but the *Bar* suit, in its monochromatic asceticism, celebrated the cinched in female body and defined a defiant yet decorous temperament, embodied by resourceful horsewomen of years gone by who had chosen to ride sidesaddle rather than forgo their freedom. The *Bar* suit imposed an authoritative presence that would be echoed by *Miss Dior*, the first green chypre in the history of perfume, in an amphora-shaped Baccarat bottle, whose neo-classical curves were a miniature of the *Bar* suit's full skirt. It was as though the couturier wanted to draw a line through the times of fear and forget the years of ration cards, the shapeless cardigans, and bicycle breeches. To turn the page and go back to the very essence of couture, "of clothing women and enhancing their beauty."[7]

The chosen one was none other than Tatiana Kousnetzoff, alias Tania. Christian Dior would say of her that among all the models whom he knew, "she was one of the most naturally and most extraordinarily talented at the job." Born in Nice in July 1925, Tania was the very first model hired by the house of Dior on December 16, 1946. And it was Tania who wore the famous suit. And it was she, too, whom Christian Dior described as his goddaughter. A brunette noted for her extremely slender frame, she carried off the designs with all the panache of a princess—like the princess that she was to become, twenty-five years later, after she opened her own couture house in Italy. She had "the quality of being a mannequin turned into a woman rather than a woman turned into a mannequin.... Tania is femininity itself, with her ruses, her fibs, her little scenes, and also her grace, her sweetness, and her loyalties. If, in the world of fashion as in the theater, legends exist, then Tania will certainly be one of them."[8]

"If you could have only one garment in your wardrobe, I should say it is best to have a suit," confided Christian Dior in 1952 to *Woman's Illustrated*.[9] Three years later on August 3, 1955, 4,000 international students enrolled in a French civilization class welcomed a distinguished visitor to a Sorbonne lecture hall: Christian Dior had come to give a lecture on the theme of "the aesthetics of fashion" with a retrospective show of his designs, from the New Look to the *Y* line. It is interesting to note the importance that Christian Dior placed on "sketches," "architecture," and "sculpture" in the lecture, introducing these themes before he

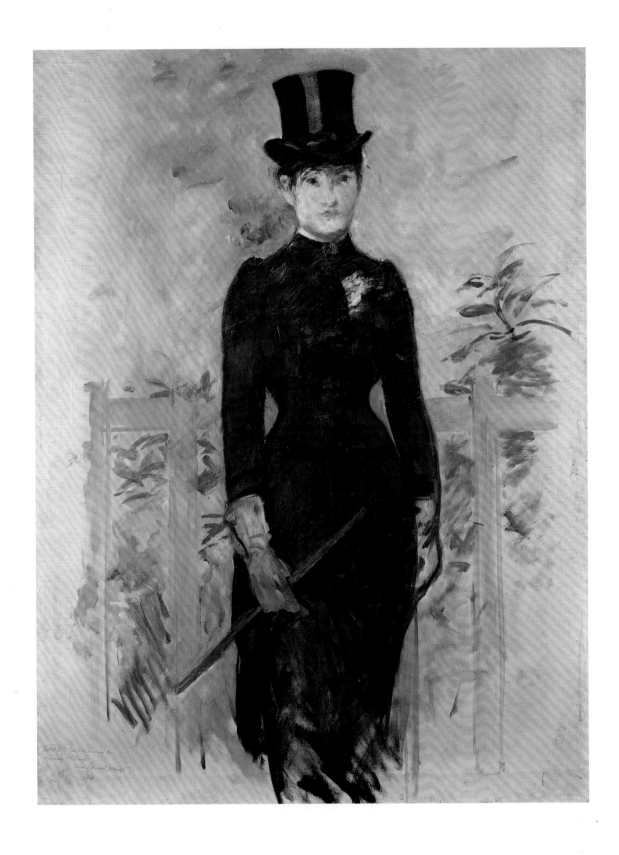

Édouard Manet, *Amazone (Mademoiselle Henriette Chabot)*, 1882.
Oil on canvas. Private collection.

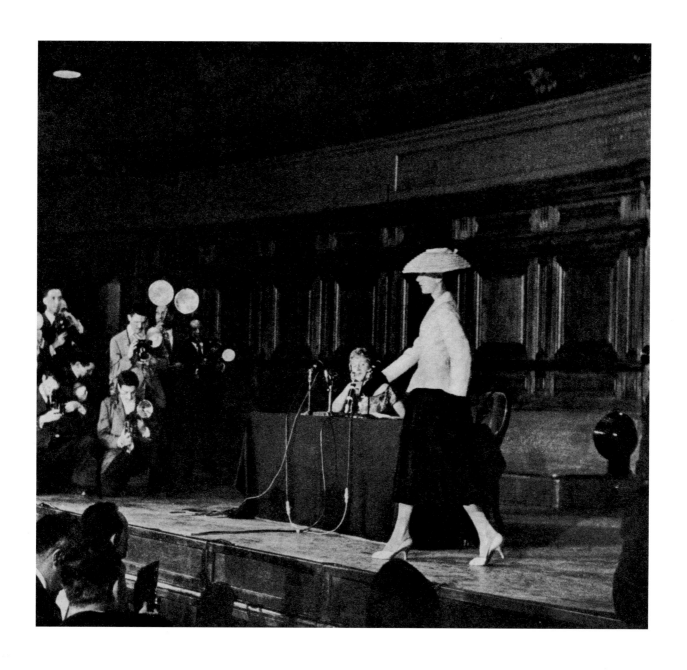

The *Bar* suit shown at a lecture given by Christian Dior at the Sorbonne, 1955.

18

even talked about fashion. "The so-called sculpted element in the current execution of a dress lies first in a sort of framework, although the word framework is ill-suited to describe molding the shape of the body in a light toile fabric the seamstresses use to adjust the dress. The toile is a veritable sculpture that remembers shape, thanks to what we call a stroke of the iron, and thanks to the work of this iron, which we use in the same way a sculptor uses his tools."

The same day, a photo session was organized on the banks of the river Seine, with Willy Maywald behind the lens. It was he who would capture the lines set forth by Christian Dior with his now cult photograph (*see* p. 13). The couturier, who that day confessed to having dreamed of being an architect, thereby took part in the rewriting of an icon. Eight years after its creation, the *Bar* suit gained a new set of accessories: the black heels christened Goya pumps by the Americans were now white, with a less rounded, sharper toe, while the black, raised-brim hat had been replaced by a *tonkinois* straw hat, worn by Renée, a Dior fitting room "fairy." But in particular, the jacket collar presented in 1947 in a "shawl" version, had been refined into a "suit", notched, stiffened with canvas, and pressed. It was all as though Christian Dior, in his concern for streamlining and perfection, was highlighting a sketch and condensing its expression to make the *Bar* suit an absolute. The same, and yet different; it was one of his precious talismans. For the man who presented almost two hundred designs each season understood the need to define in one stroke a silhouette that would break the mold forever. The New Look was a signature that defied the ephemeral.

The passage of time can be measured through the house of Dior, which once employed ninety people in its three ateliers and is now an empire. Occupying five buildings with twenty-eight ateliers, it creates more than half of French haute couture exports. Christian Dior, the virtuoso of new fashions, marked a turning point as he masterfully drew the future of an endlessly variable alphabet primer. Made in the image of the black letters that stood out on the neoclassical stucco medallion designed by Victor Grandpierre, the *Bar* suit was, and will always be, his portrait, combining all that was most precious to the designer: "My prime inspiration is the shape of the female body: for it is the duty of the couturier to adopt the female form as his point of departure and the use of materials at his disposal so as to enhance its natural beauty. I could perfectly well design a whole collection simply in black or white and express all my ideas to my complete satisfaction."[10]

The *Bar* suit was one of the key pieces of the New Look—a shape set in time and space, whose poetic lines were magnificently rendered by René Gruau. On the chessboard of fashion, Christian Dior reinvented the game, attentively reviving

pleating techniques in particular, accentuating waists, and adding a curve to the hips. It was "a return to all that was becoming and pretty," drawing on the couturier's three major sources of inspiration: the eighteenth century, the Second Empire, and the Belle Époque. In his own way, the couturier revealed the very process of his profession in the sketch and the "structured toile" that he so cherished. In 1955, Christian Dior designed more models than any other house (712 compared to 222 at Chanel and 203 at Nina Ricci), and sold more, too (5,154 compared to 4,140 at Jacques Fath and 300 at Chanel). The *Bar* suit created an identity that became an integral part of Paris, and for buyers the world over, this archetype would forever embody the "Paris look." In 1895, John Redfern died, ten years after the invention of the tailored suit. It would be ten years exactly between the creation of the New Look and the death of Christian Dior in 1957.

"I hope it's worth the journey," said Carmel Snow. Few remember that on February 12, 1947, it was eight degrees Fahrenheit outside in the coldest winter Paris had seen since 1870. But that day the thermometer had a rival: the *Bar* suit, which headed the New Look line-up. This was the loom on which Christian Dior had woven the future of the house. It was a lucky line and a fragrant visiting card, radiating such joy that Christian Bérard gave it a mist of pink powder in his watercolor illustration. It was a magical suit whose principle vocation, just like a perfume, Christian Dior affirmed, was to "create an aura around you."[11]

[1] Christian Dior, *Dior by Dior*, V&A Publishing, London, 2012, pp. 22-23.
[2] René Clair, reception speech at the Académie française, 1962.
[3] Henri Barbusse, *L'Enfer*, Éditions Albin Michel, Paris, 1908.
[4] Christian Dior, *op. cit.*, p. 4.
[5] Christian Dior, *Woman's Illustrated*, No. 834, October 25, 1952.
[6] Christian Dior, *op. cit.*, p. 28.
[7] *Ibid.*, p. 27.
[8] *Ibid.*, p. 129; Christian Dior, *Christian Dior et moi*, Bibliothèque Amiot-Dumont, 1956, np.
[9] Christian Dior, *Woman's Illustrated*, No. 830, September 27, 1952.
[10] Christian Dior, *op. cit.*, p. 70.
[11] Christian Dior, *Woman's Illustrated*, No. 834, October 25, 1952.

Carmel Snow (left) with the photographer Louise Dahl-Wolfe attending a Dior show.

The *Bar* suit, Spring-Summer 1947 Haute Couture collection, *Corolle* line.
Photograph by Patrick Demarchelier.

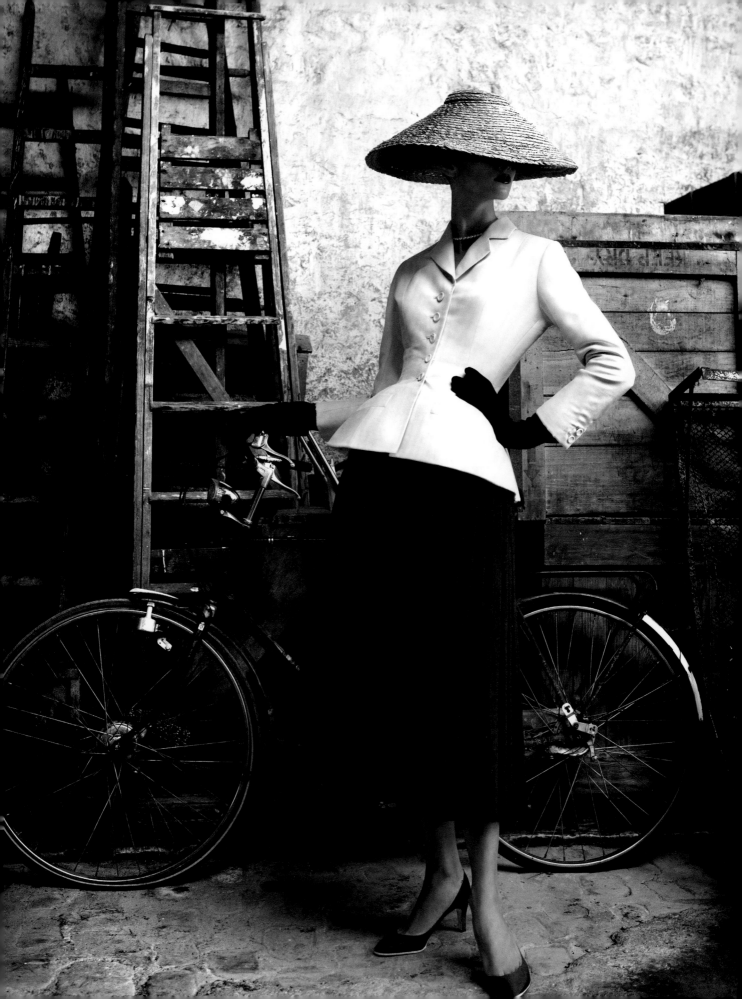

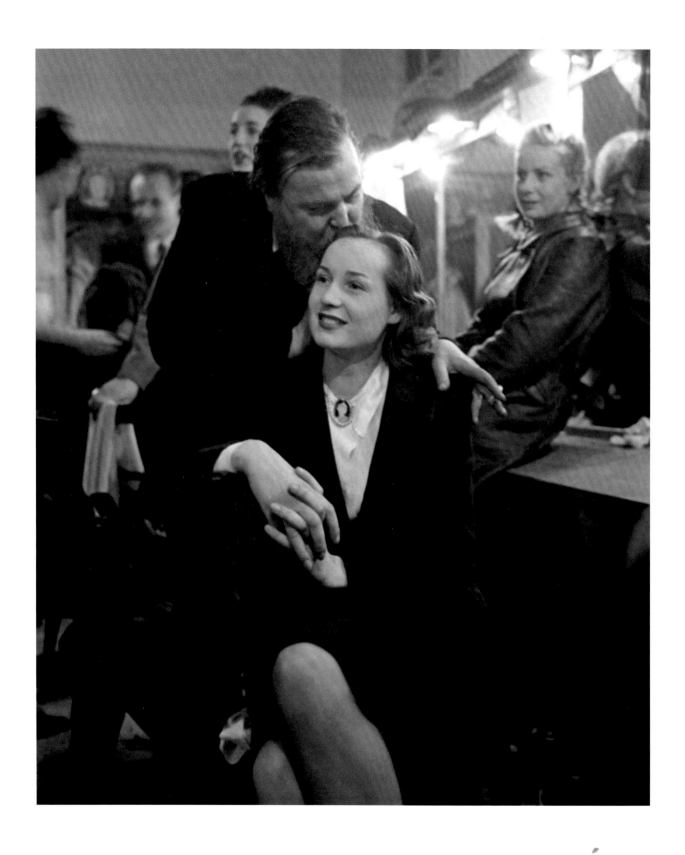

Christian Bérard and model Marie-Thérèse in the Dior fitting room
at the house's first show in 1947. Photograph by Eugene Kammerman.

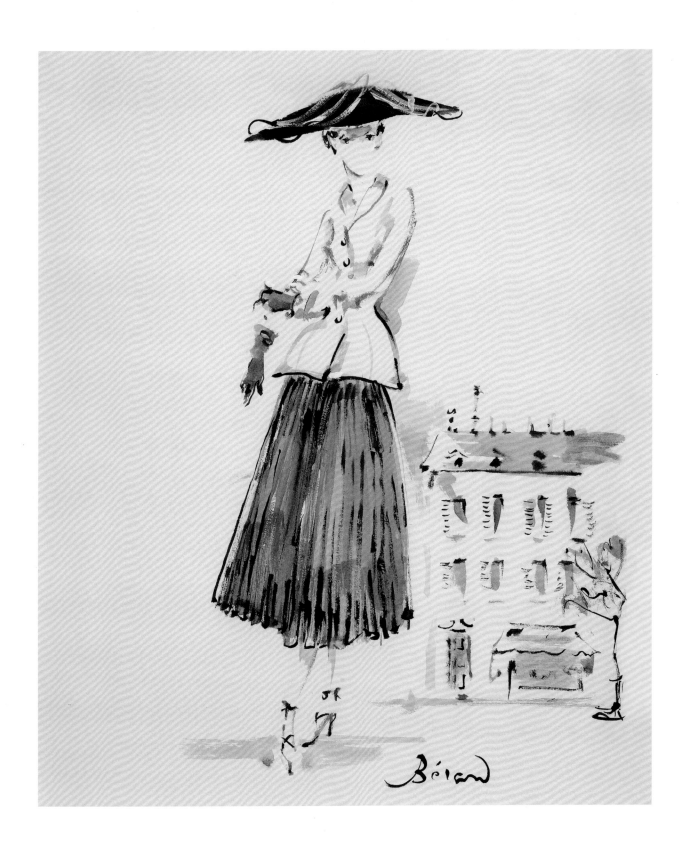

Illustration of the *Bar* suit by Christian Bérard, 1947.

Christian Dior

COLLECTION PRINTEMPS 1947

———

Les lignes de cette Première Collection de Printemps sont typiquement féminines et faites pour mettre en valeur celles qui les portent.

2 Silhouettes principales :

La silhouette " COROLLE " et la silhouette en " 8 "

" COROLLE " : dansante, très juponnante, buste moulé et taille fine.

" 8 " : nette et galbée, gorge soulignée, taille creusée, hanches accentuées.

Les jupes allongées nettement, les tailles marquées, les basques de jaquettes souvent écourtées, tout contribue à élancer la silhouette.

Seules les robes de fin de journée ou de grand soir sont largement et doucement décolletées.

L'asymétrie, le trop grand emploi du drapé et l'entrave ont été volontairement évités.

Coloris dominants : Marine - Gris - Grège et Noir.

Quelques teintes discrètes : Royal kaki.
Bleu de Paris.
Terre de Paris.

Quelques tons éclatants : Rouge Scream.
Vert Longchamp.
Rose Porcelaine.

Imprimés exclusifs : Pois et carrés sur twills de teintes discrètes.
Imprimé " Jungle " sur crêpe et mousseline.

Les chapeaux volontairement simples, précisent la silhouette voulue.

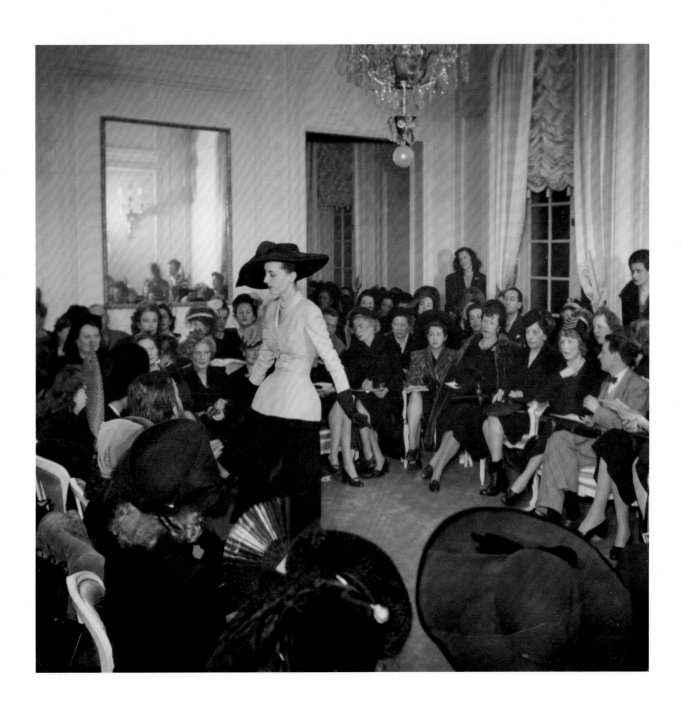

ABOVE Model Tania presents the *Bar* suit at the house's first show,
Spring-Summer 1947. Photograph by Pat English.

OPPOSITE Program from Christian Dior's first collection.

Marion Cotillard wearing the *Bar* suit, 2012.
Photograph by Jean-Baptiste Mondino.

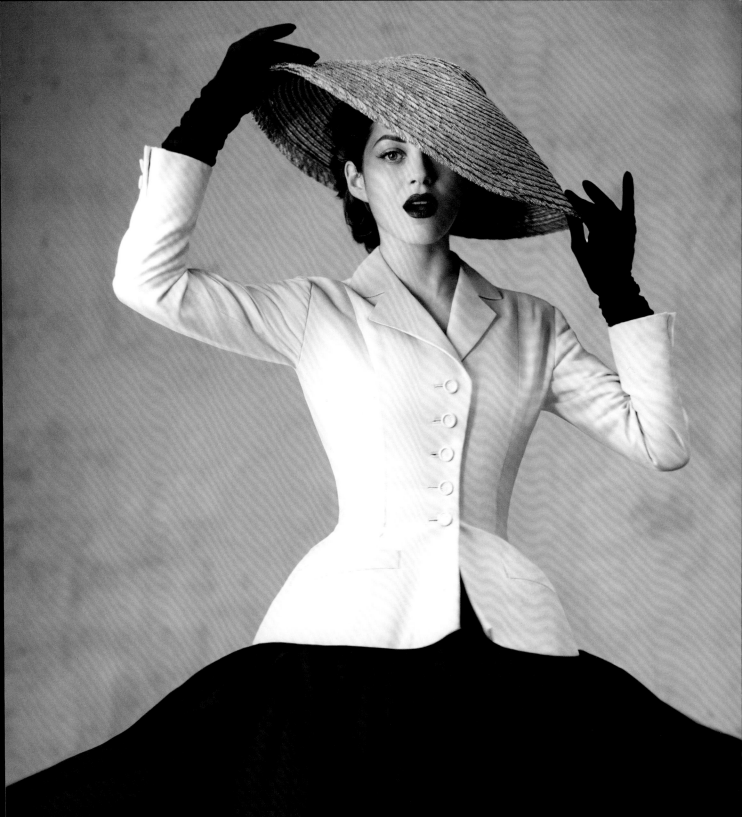

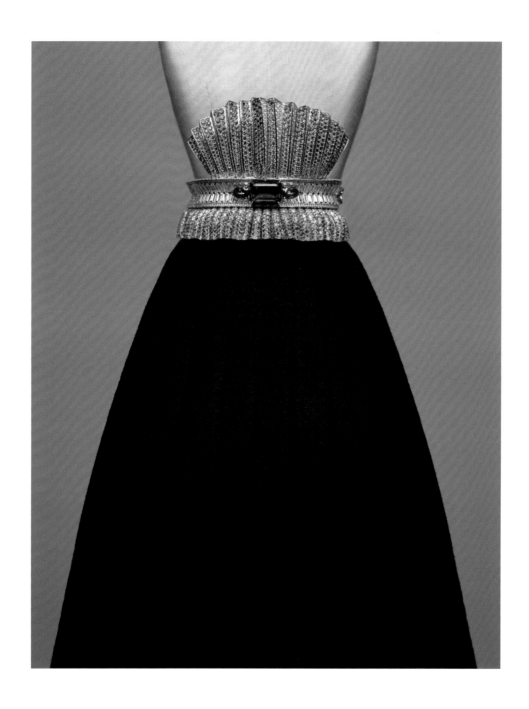

ABOVE *Archi Dior Bar en Corolle Émeraude* bracelet, Dior High Jewelry.
Photograph by Brigitte Niedermair.

OPPOSITE The *Bar* suit, Spring-Summer 1947 Haute Couture collection, *Corolle* line.
Photograph by Brigitte Niedermair.

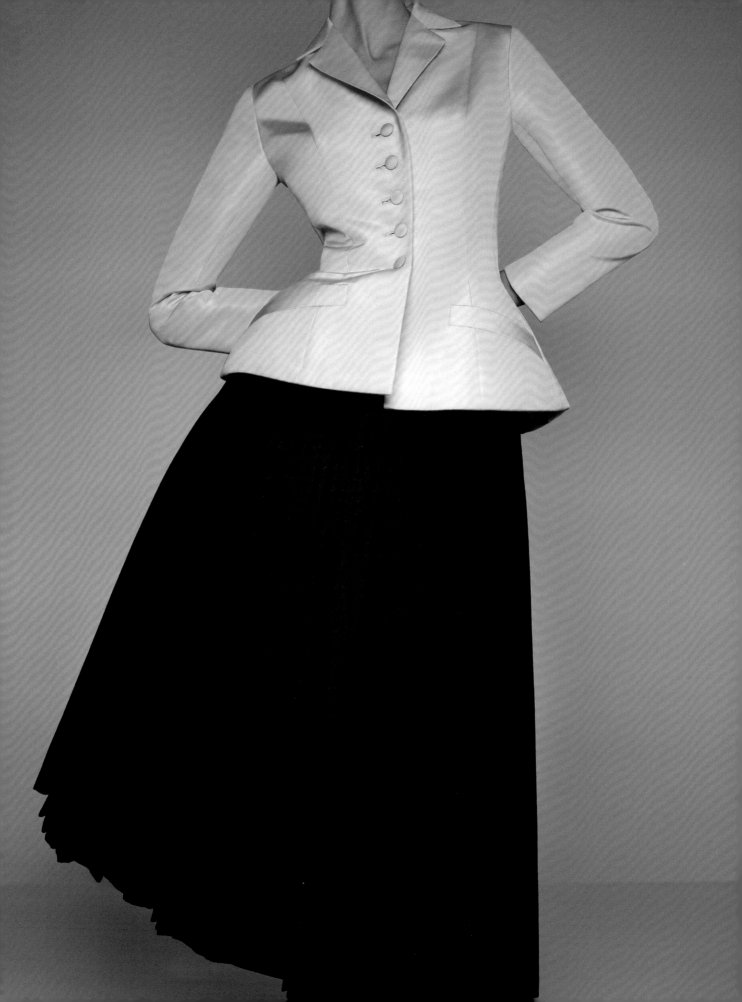

The Case of the Skirt

On August 8, 1953, the cover of the weekly magazine *Paris Match*, which displayed an image of Christian Dior measuring the length of a skirt with a tape measure, created a scandal. "If you think that all sense of moderation is lost in the art world and to architects, and that a few centimeters on a woman's skirt is revolutionary in 1953," said an astonished Jean Cocteau, "then you are talking about the Dior bomb as seriously as people are starting to talk about the atomic bomb."[1] The *Vivante* line marked a turning point and a new break with convention, the first of which had been initiated in 1947 with the New Look and the famous *Corolle* skirt of the *Bar* suit. For Marcel Boussac, the textile magnate who had provided financial backing to the house of Christian Dior since December 1946, the stakes were high. Alongside the "cinched waists," the "markedly lengthened skirts" announced in the program provoked great fascination and hostility. "The New Look was first and foremost about the fullness of its skirts! And then of course, the cinched waists..." recalls Hubert de Givenchy. "Everyone was surprised by the amount of fabric used after all the years of deprivation. Suddenly, everything else looked old-fashioned. I even saw women adding bits of fabric onto their skirts."[2] In the United States, Christian Dior would be accused of "wanting to hide the sacred legs of the American woman." In Chicago, he saw "furious maenads" brandishing placards that read, "Down With the New Look! Burn Monsieur Dior! Christian Dior, Go Home!"[3]

[1] Jean Cocteau, "Journal, Sunday, August 16," *Le Passé défini*, volume III, Gallimard, Paris, 1954.
[2] Interview with the author, January 13, 2015.
[3] Christian Dior, *Dior by Dior*, V&A Publishing, London, 2012, p. 47.

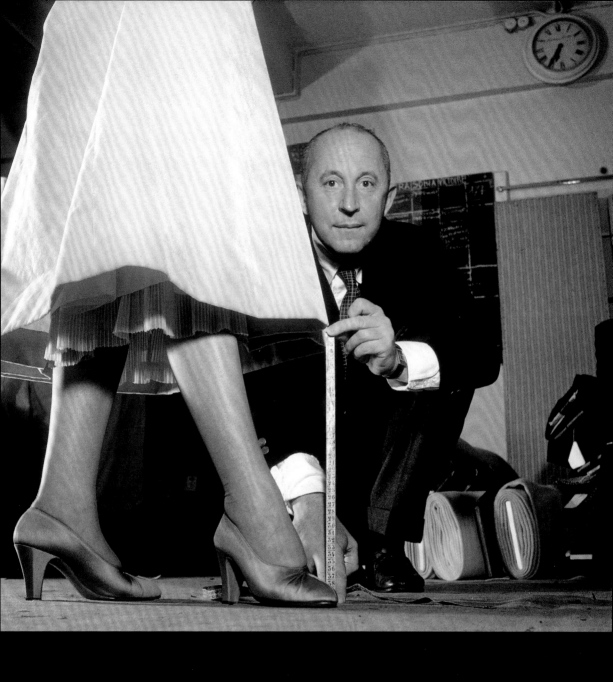

Christian Dior photographed by Willy Rizzo for *Paris Match*, 1953.

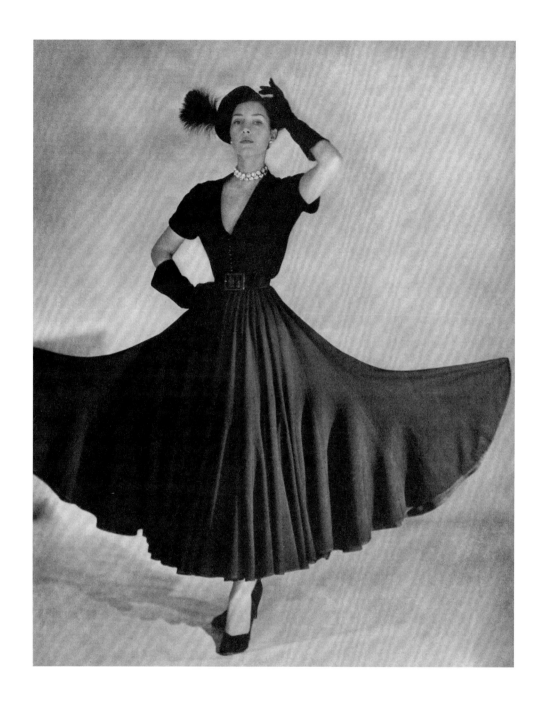

OPPOSITE *Diorama* dress in black wool crepe, short-sleeved close-fitting bodice, cinched
at the waist with a black leather belt, very full skirt trimmed with black braid as at the neck.
Autumn-Winter 1947 Haute Couture collection, *Corolle* line.

ABOVE The *Diorama* dress photographed by Erwin Blumenfeld.

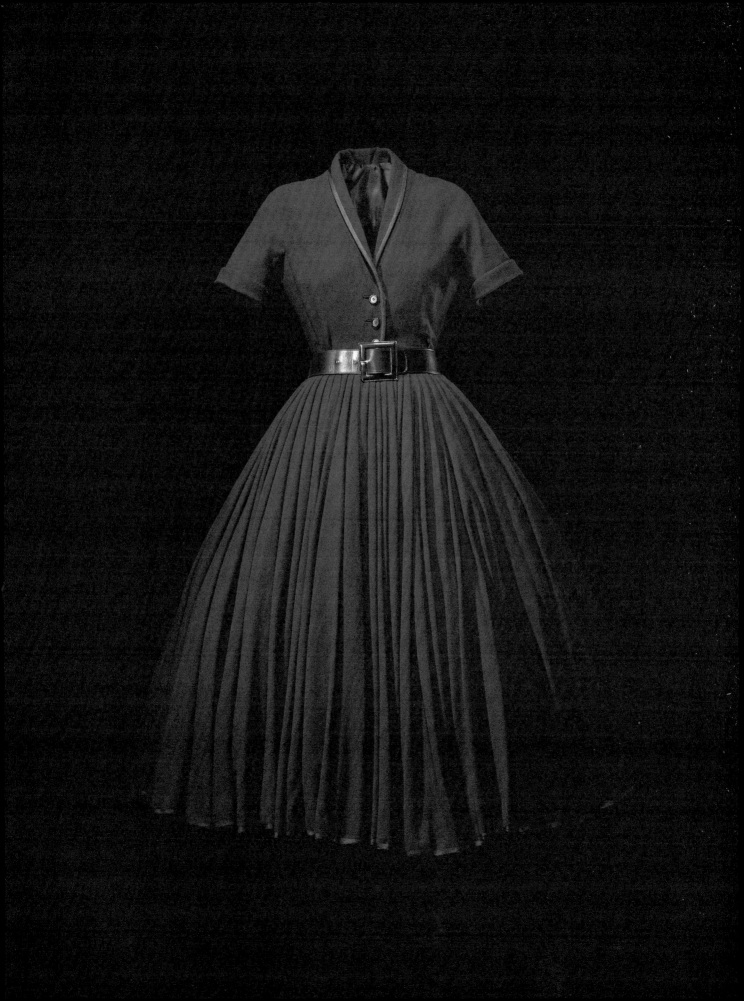

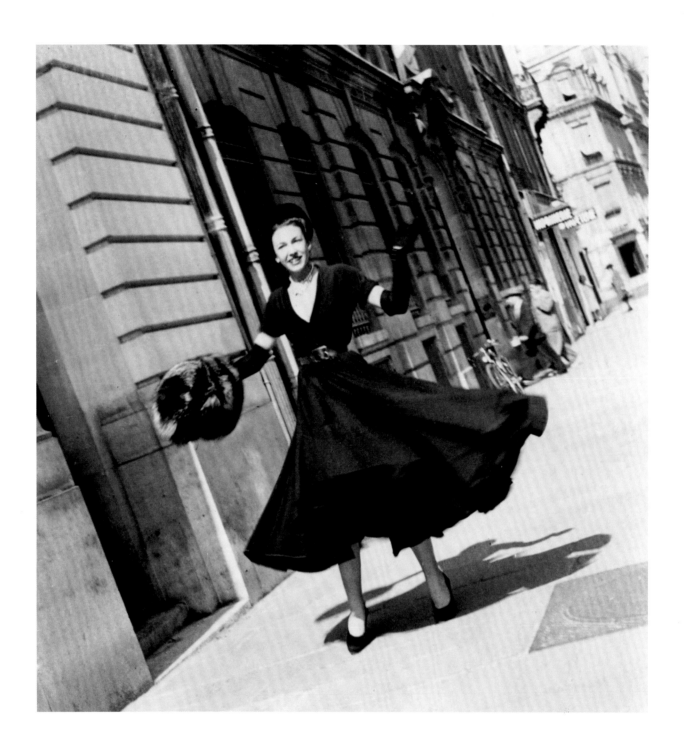

ABOVE *Diorama* dress, Autumn-Winter 1947 Haute Couture collection, *Corolle* line.
Photograph by Sante Forlano.

OPPOSITE Two dresses from the Autumn-Winter 1947 Haute Couture collection, *Corolle* line.
Photograph by Erwin Blumenfeld.

36

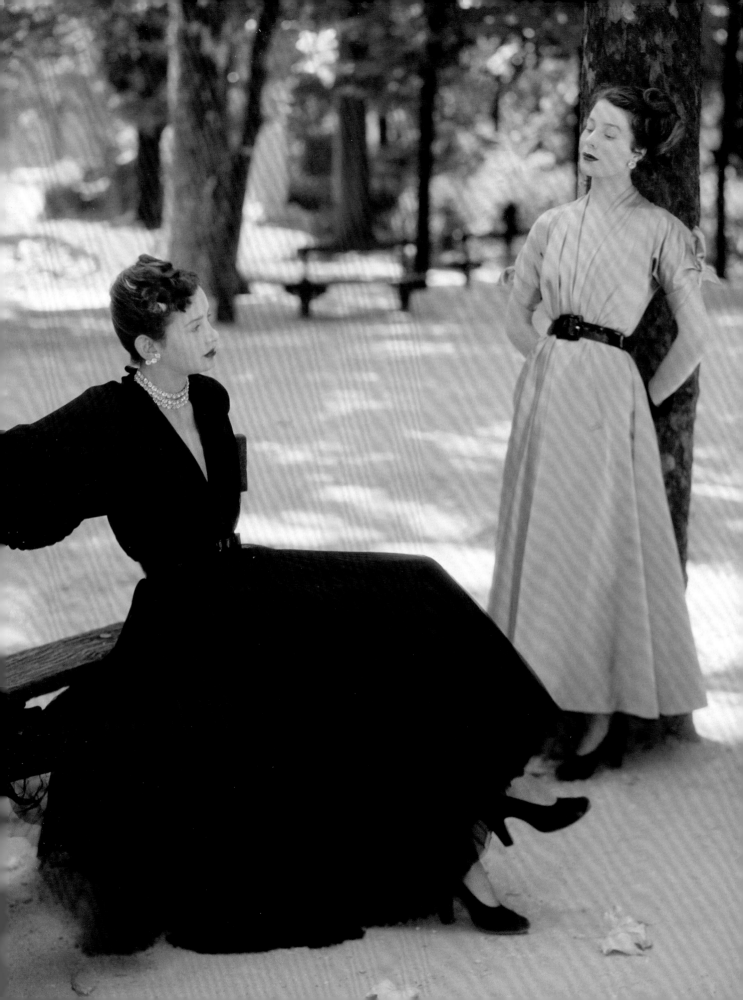

Corolle afternoon dress in black wool, Spring-Summer 1947
Haute Couture collection, *Corolle* line.

Shimmering Reviews

On February 12, 1947, Christian Dior, "that nimble genius unique to our age with the magical name combining God (Dieu) and Gold (Or)," as Jean Cocteau put it, was to witness and instigate a veritable triumph. The media rocket was launched. "A new look, a new vision, a new era, a new appearance, a new aspect, and a new style. The following day, the word was in every fashion magazine, except for those in Paris, as they were on strike."[1] The verdict was in. The English-language press was impassioned. "Christian Dior Has Brilliant Paris Opening" was the headline in *Women's Wear Daily* the day after the show. The *Herald Tribune* spoke of "the sensation of the season," and on March 18, 1947, the New Look was on the cover of *Elle*. Two weeks later, it was *Vogue*'s turn to celebrate Christian Dior, "a new house with new vigor, new ideas." *Life*, which dedicated four pages to the phenomenon, spoke of the "surprise success" of the house of Dior. Henri Cartier-Bresson photographed Christian Dior, to whom April 1947 *Harper's Bazaar* awarded an ovation: "The *agent provocateur* and hero of the day is the couturier Dior. He is revolutionizing daytime fashions as Poiret did in his day and Chanel in hers." And the magazine was quick to quote a comment from a Parisian taxi driver: "I hear that there is a rival to Balenciaga, at last."

[1] Pierre Stéphany, *1944-1947. La guerre et après*, Ixelles Éditions, Brussels, 2011.

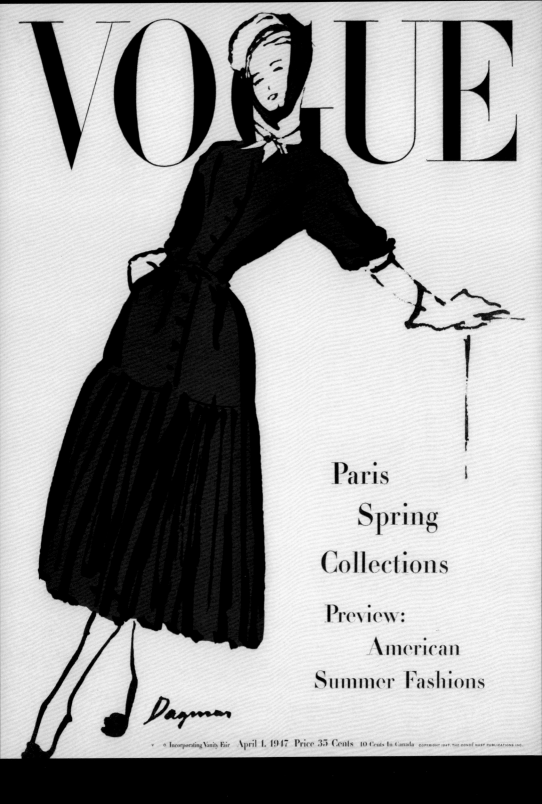

VOGUE

Paris
Spring
Collections

Preview:
American
Summer Fashions

Dagmar

v o Incorporating Vanity Fair April 1, 1947 Price 35 Cents 10 Cents In Canada COPYRIGHT 1947. THE CONDÉ NAST PUBLICATIONS INC.

American *Vogue*, April 1, 1947.

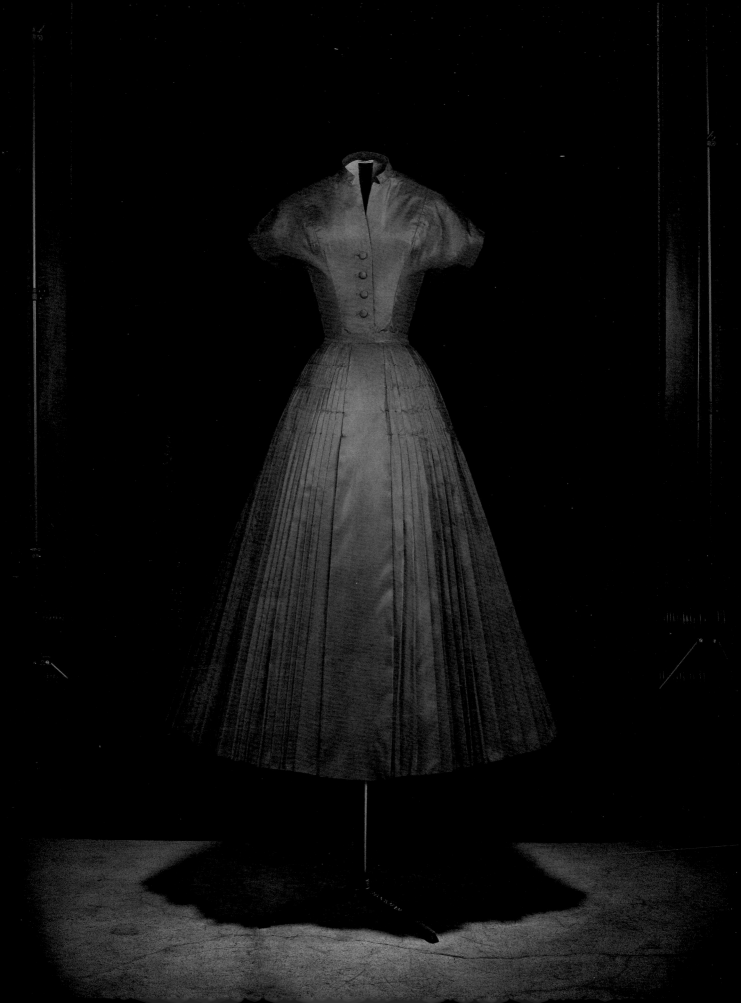

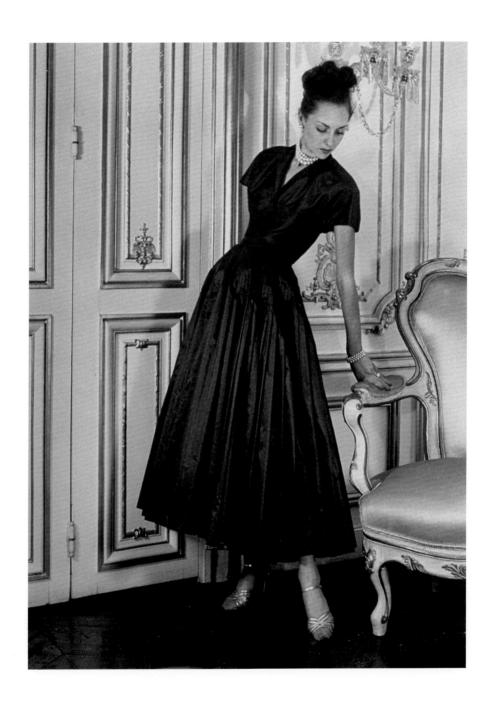

OPPOSITE *Chérie* dress in navy silk taffeta,
Spring-Summer 1947 Haute Couture collection, *Corolle* line.

ABOVE Model Tania wearing the *Chérie* dress. Photograph by Pat English.

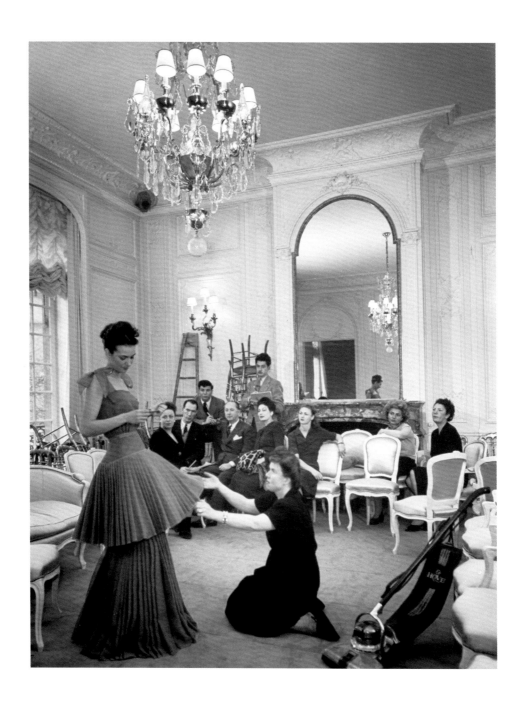

OPPOSITE *Soirée* evening gown in navy taffeta with a veil of black point d'esprit tulle.
Spring-Summer 1947 Haute Couture collection, *Corolle* line.

ABOVE Preparing the Spring-Summer 1947 Haute Couture collection;
Marguerite Carré adjusting the *Soirée* gown. Photograph by Pat English.

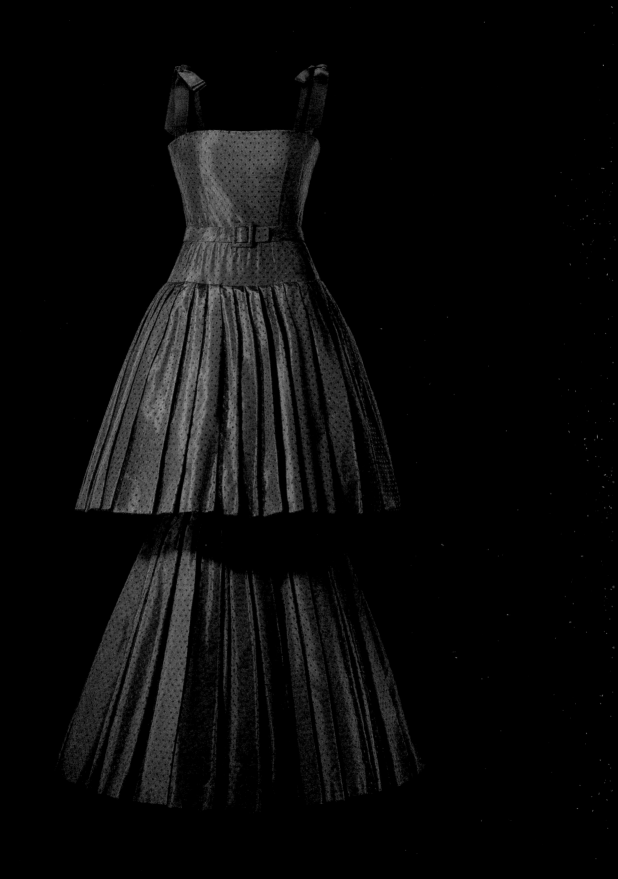

The Essence of a Friendship

The *Bar* suit made its entrance into perfumed salons. Its fragrant alter ego was none other than *Miss Dior*, the fruit of a collaboration between Christian Dior, Paul Vacher the perfumer, and Serge Heftler-Louiche. The latter was a childhood friend from Granville who would run Christian Dior Parfums, which he and the couturier had just set up. A show was seen as a celebration, and the surrounding décor had to be brimming with joy and creativity—and even with scent. "Spray more perfume!" the couturier instructed. On February 12, 1947, more than two pints of this green chypre were spritzed into the salons at 30 avenue Montaigne.

Adding to the opulent bouquets of delphiniums, sweet peas, and lilies of the valley, the scent expressed, as much as the *Bar* suit, the spirit of rebirth, and an air of rediscovered youth and hope. "*Miss Dior* was born of those Provençal evenings alive with fireflies, where jasmine plays a descant to the melody of the night and the land," Christian Dior wrote about this first perfume. It was like a fresh breeze embodying the joie de vivre personified by Catherine, one of the couturier's sisters. In the image of the *Bar* suit, *Miss Dior* imposed itself as a signature scent, which has today been reinterpreted with consummate skill by François Demachy, Dior perfume creator. Today's bottle, with a "couture bow" at its neck, remains iconic. For is it not, in the words of Christian Dior, "cut like a suit"?

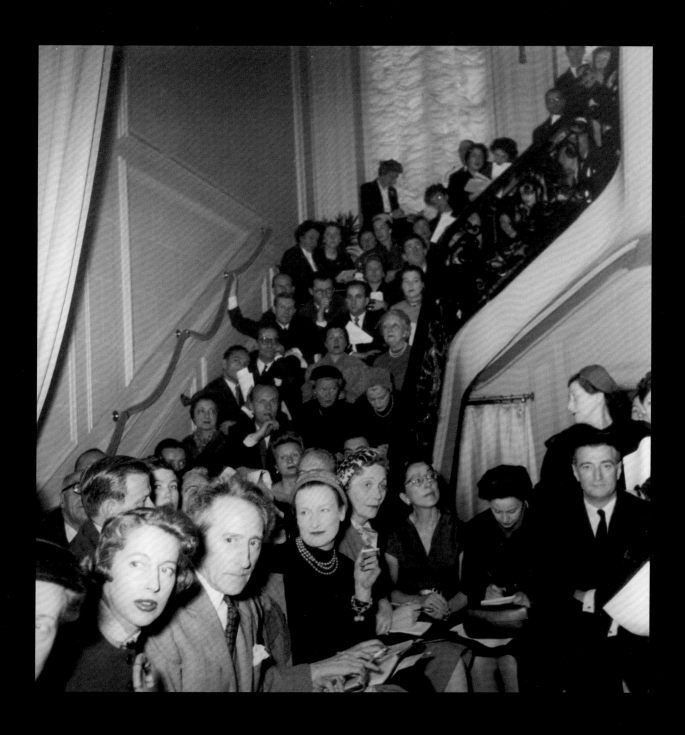

Christian Dior presents a collection, not only to the press and buyers, but also
to his friends, including Jean Cocteau and Francine Weisweiller who sit side by side,
not far from Serge Heftler-Louiche (first on the right), circa 1954.

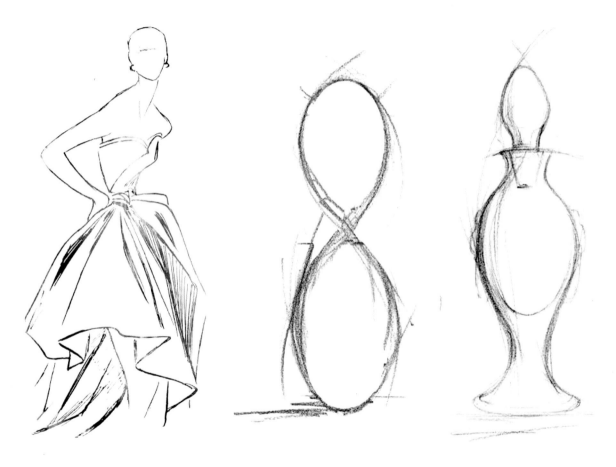

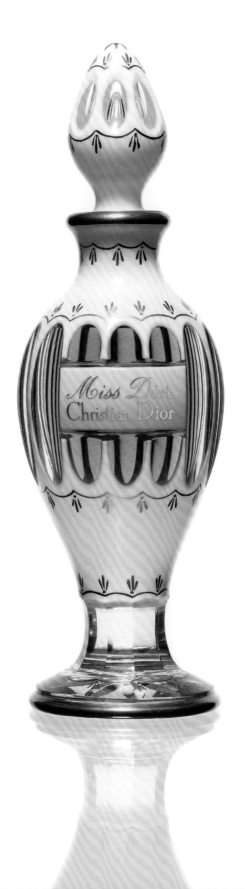

II

EXPERTISE, LINE, AND STRUCTURE

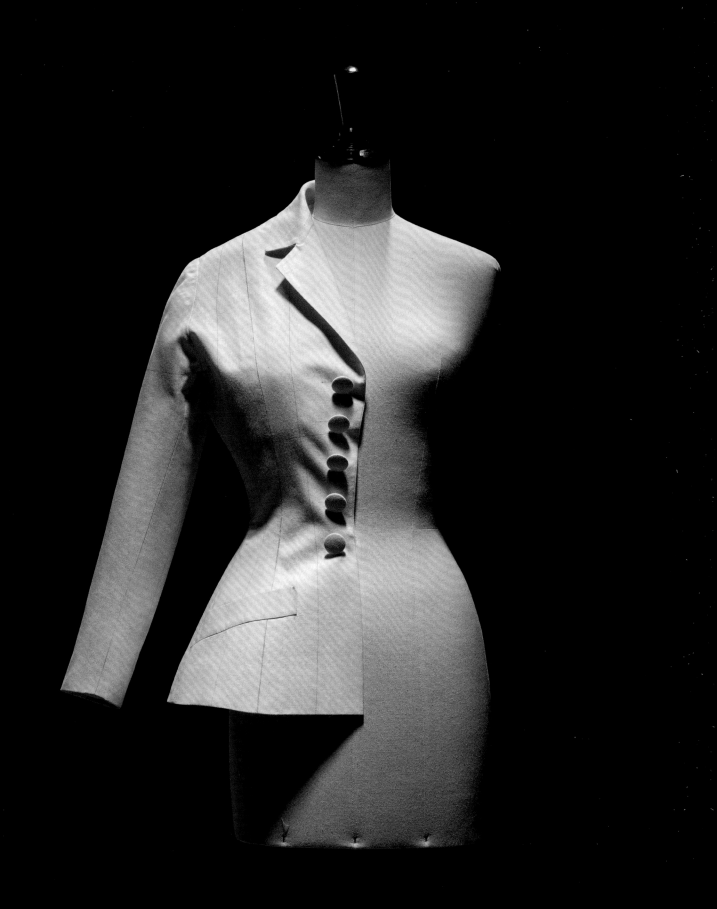

The Body in Bold Strokes

"It only needs the indifference of one person to destroy the whole climate of passionate collective research,"[1] wrote Christian Dior. In 2015, in the Tailoring atelier of Madame Monique on the fifth floor at 30 avenue Montaigne, Laurence, the second in command, remembers Antoinette, not without emotion. Apprentice seamstress in 1947 and head seamstress in 1987, Antoinette made two *Bar* suits, one of which was presented to the Musée des Arts de la mode in Paris on the fortieth anniversary of the house of Dior, and therefore, of the New Look. "We all wanted to learn... The *Bar* suit was the absolute reference, it was all about the lines... For Antoinette, this suit gave meaning to her life and to everything she had learned at Dior." The designs presented to Christian Dior by Marguerite Carré, who headed the workrooms, were covered in directional threads, while imagination found resonance only via the strictest discipline. Sweaty palms were not acceptable, for "if our palms perspired, the mousseline became damp and would then 'cry,' and go flat." The criterion was draconian: dry palms from January 1st to December 31st!

As a counterpoint to an era of restriction in which nothing should go out of fashion before it was worn out, the *Bar* suit became an ambassador of Dior's expertise. A Dior seamstress was reflected in the figures, which in 1947 spoke for themselves: 9,840 yards of fabric, 22 miles of pattern toile, and 100,000 hours of labor for each collection. All of which caused Bettina Ballard, a friend from Dior's Lelong days, to say, "We witnessed a fashion revolution." In 1947, an English client, having acquired the reproduction rights to the famous *Bar* suit, made a flannel version of it and sold almost seventy of them in less than two weeks. It was a seismic shift in textiles, given that only five years previously, the Making of Civilian Clothing (a restriction order) had specified the maximum circumference and length of a skirt, while also limiting the number of pleats allowed. More specifically, the maximum authorized width of a skirt was six feet, while "the fabrication notes indicate that the *Diorama* skirt required twenty-eight yards of fifty-one-inch-wide fabric, and twenty-seven yards of thirty-five-inch-wide black faille."

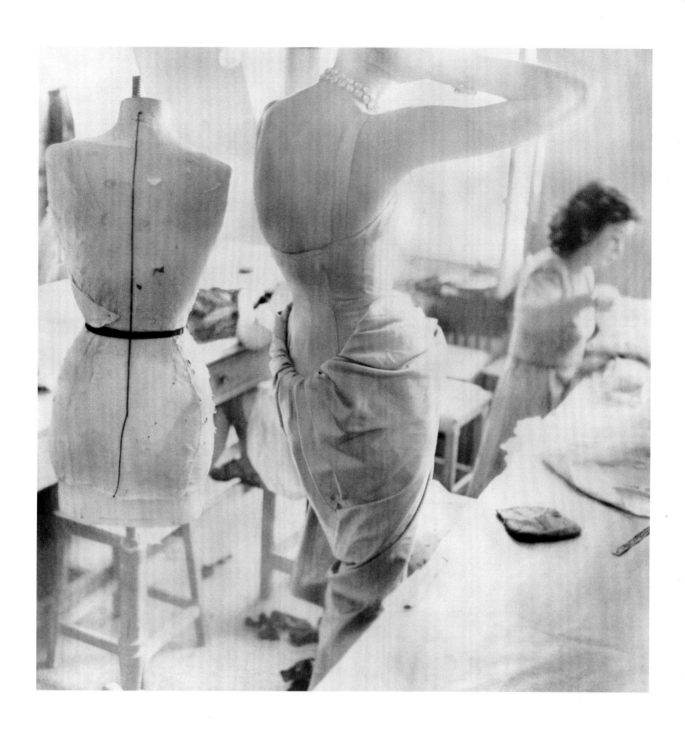

PREVIOUS PAGE A half-toile of the *Bar* suit jacket,
Spring-Summer 1947 Haute Couture collection, *Corolle* line.

ABOVE Workroom, house of Dior, Paris, August 1947.
Photograph by Richard Avedon. © The Richard Avedon Foundation.

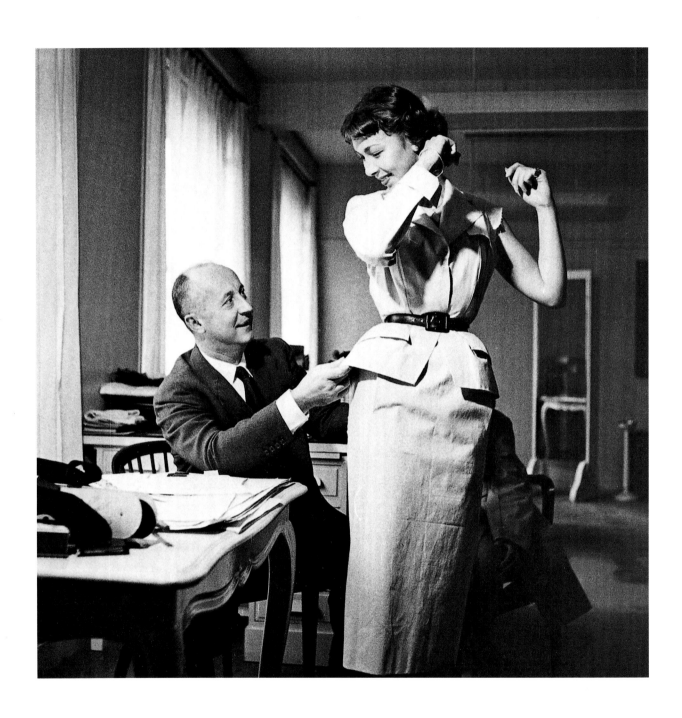

Christian Dior adjusting a design, circa 1950. Photograph by the Seeberger Brothers.

In the inaugural collection, one notices the use of much finished tulle, wool, glazed faille, horsehair, piqué, percale, and woolen fabrics, which required *mastering* and *managing*. The passage of time seems not to have erased the tradition; instead it has been strengthened by technique and in particular by the entrenched values of the profession, defying the ages: "The workrooms seem to be able to decipher an unbreakable code," explained Christian Dior, "They keep their heads among a forest of pins, apparently stuck in completely haphazardly, and a spider's web of threads. I have never been able to understand how they manage it."[2]

Arriving at the "finishing point" was a moment cherished by Christian Dior. He would look again and again at the back and sides of a design, move a seam, deepen a décolleté, remove a dart and replace it with some neat pressing. Within the house, the *Bar* suit held a rather particular place, for it was an absolute exercise in style, presenting issues such as avoiding puckering at the shoulder. Its creation required 150 hours of work. Several years ago, a client ordered a vintage jacket to wear with a pair of pants. "Shantung puffs up easily," the Tailoring atelier explains. "It is not always easy to get a lovely clean line with this fabric—it can get damaged. If we can't fix it, we have to change the piece. And ivory is so unforgiving."

Therein lies the challenge, the veritable exercise in style that measures up to the standards set by Christian Dior, like a true lesson in deportment, bearing, and posture. "The only thing that would force us to stop would be if we fainted. But I don't think that ever happens to me," says the model Renée, so slender in her shantung jacket. Is the *Bar* suit not, first and foremost, about redesigning and enhancing the body according to a new ideal of proportion? "Thus I molded my dresses to the curves of the female body so that they called attention to its shape. I emphasized the width of the hips and gave the bust its true prominence,"[3] wrote Christian Dior.

With such a structured appearance, the *Bar* suit summarized a series of unwritten lessons in keeping with its history and was a talisman par excellence. "The Chambre Syndicale de la Couture invited Christian Dior to its fashion night," recalled Suzanne Luling—who was the house of Dior sales director and a childhood friend of Christian Dior in Granville. "Lucie Noël telephoned us to share the surprise that she was planning for him, which was to present the *Bar* suit. But where was it? Everyone knew, everyone was sure of it. Someone had put it *here*, someone else had seen it *there* last time, but it had disappeared! It was not to be found either in the studio or the fitting room, in the advertising department or even Christian's office. There was a general feeling of panic, and, finally, in desperation, we decided to search everywhere that a box containing a suit could possibly be found. We stooped down, raised curtains, and moved toiles out of the way, and then, standing on a

chair, balancing on tiptoe, someone found it. Guess where? At the back of a shelf in the bathroom where Jeannine, the cleaning lady, had respectfully and carefully hidden it away to protect it from overzealous admirers."

It is funny to think that the *Bar* suit, so carefully tucked away in the house of Dior archives with the collection charts and programs, was a kind of silent witness to a story, fed on obsessions and unwritten laws, that everyone knew by heart. It would seem that nothing has changed since the era when Marguerite Carré would present designs to Christian Dior covered in an array of pins and crisscrossed in draping tape. In the most exacting search for line and balance, the *Bar* suit followed a strict discipline. Loose biases were needed to ensure that the collar was not slack. As for the skirt (no less than thirteen yards of it!), it called for more than merely simple accordion pleats: "Visually, it looked like all the pleats were equal. Yet it began on the straight grain. To get this bias, you had to play with the hollows, pleating with multiple resources," explained Madame Monique. "Underneath were petticoats of tutu tulle." The final objective was balance and mastery of proportions in this job that required rigor above all else. "All of that was finely worked, over and again."

With three yards of lining, the *Bar* suit went hand in hand with the famous "cushions" mentioned by French *Vogue* in its March 1947 editorial: "No sooner have hips appeared than they must be rounded, or else they are made to look so thanks to some clever padding in the hips of the jacket, which looks rather like one of those headless dolls used in England to cover teapots." Similarly, "Pale tussor jacket, hip-padded like a tea cosy," read the caption in April 1947 American *Vogue* beneath Serge Balkin's photo, which immortalized a model in a black Andalusian hat on the staircase at 30 avenue Montaigne. The *Bar* suit went down in history. It was the first in that line of "grand gentlemen steeped in unshakeable tradition" evoked in spring 1947 by *L'Art et la Mode*. It was a silhouette that would be echoed by Baccarat's blown glass *Miss Dior* amphorae.

At the time, the women bustled about at cutting tables that were twelve inches wide, with tradition requiring that they be sure to overturn their metal stools at the end of the day. Those tables have since been replaced by more functional, wider white tables so that toiles can be laid flat and tacking stitches sewn. Of course, some of the rituals have disappeared, starting with the presence of Christian Dior's gold-tipped rod, which was indispensable during fittings. Or, after the first rehearsal in the grand salon, the dress rehearsal where the seating arrangements were presented, with Christian Dior sitting between Jacques Rouët, the managing director, and Raymonde Zehnacker, the studio director, along with Madame Marguerite, the technical director—"Lady Couture in person," according to the

The Dior ateliers, 1955. Photograph by Robert Doisneau.

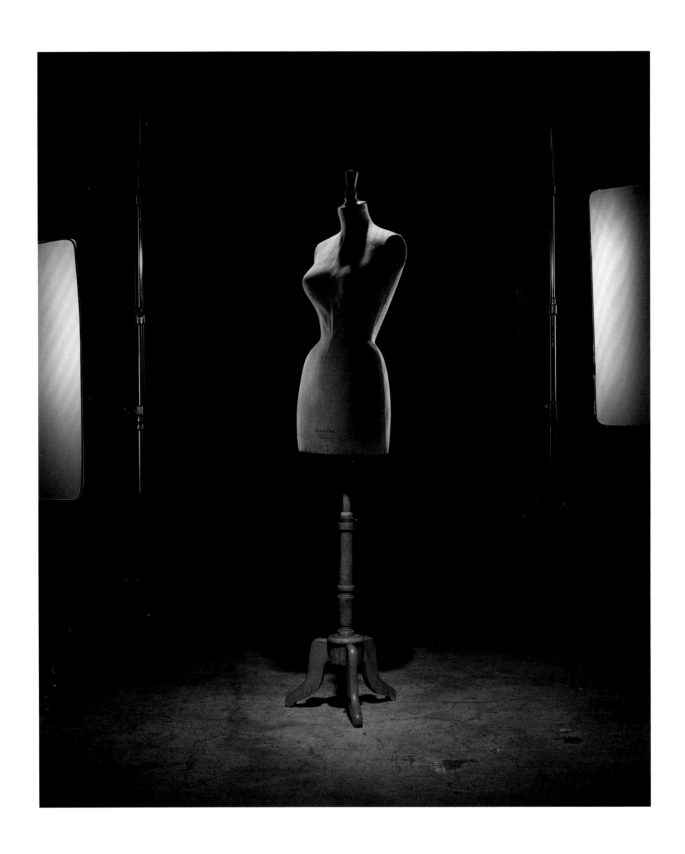

A Stockman mannequin specially created for Christian Dior.

couturier—Simone Baron of *Paris-Presse L'Intransigeant*, and Carmen Colle, wife of Pierre Colle; both were close friends of Christian Dior, whom their daughter would affectionately nickname "Tío Christian."

In 1947 the patterns were made of cloth. Today they are often made of paper: "We place the pattern on the fabric. We weigh it down. We work around it. The darts are opened." The fact remains that at Dior, the *Bar* suit—and the suit, period—always begins with a lot of interfacing. "At the time, we used wool, which was prickly, and the color even tended to run. Now we use linen, which is much nicer to the touch, but which gives less, so we always have to notch it." The technique is unfailing: "We pin everything by hand. The danger with a toile is that it gets rolled, or pulled in the wrong direction. You always have to make sure that you are not twisting it."

A back, a front, a side panel, and some piped buttonholes—the arrival of Raf Simons in 2012 marked a new stage that saw a return to the beginning with toiles, pinning, and pressing. This was followed by a more fluid approach to structure, epitomized by a "Bar" jacket that was almost a tuxedo jacket, with satin lapels and flap pockets worked on the diagonal to further lengthen the bust without tricks or prostheses. The Tailoring atelier explains, "We removed the hip padding to make it lighter." Then adds, "Raf Simons wanted all the seams to be dart stitched." The needlework disappeared beneath the handiwork, and the number of pieces needed to create a jacket was reduced by half, with less stitching and more skill and movement.

In 1947, the *Bar* suit was worn over a cotton tulle basque with metal boning. Christian Dior said, "Without proper foundations there can be no fashion," and that credo was justified by the rewriting of a new ideal, but today its importance has faded in the face of the onslaught of the natural look and the meticulous attention women pay to their figures. A naked body beneath a "Bar" suit: such is the wealth of a twenty-first century that combines history, the present, and the future from every angle. "Raf Simons prefers new fabrics for their hold. He loves pockets. He likes structure. He likes the fact that meaning lies in simplicity."

[1] Christian Dior, *Dior by Dior*, V&A Publishing, London, 2012, p. 74.
[2] *Ibid.*, p. 79.
[3] *Ibid.*, p. 23.

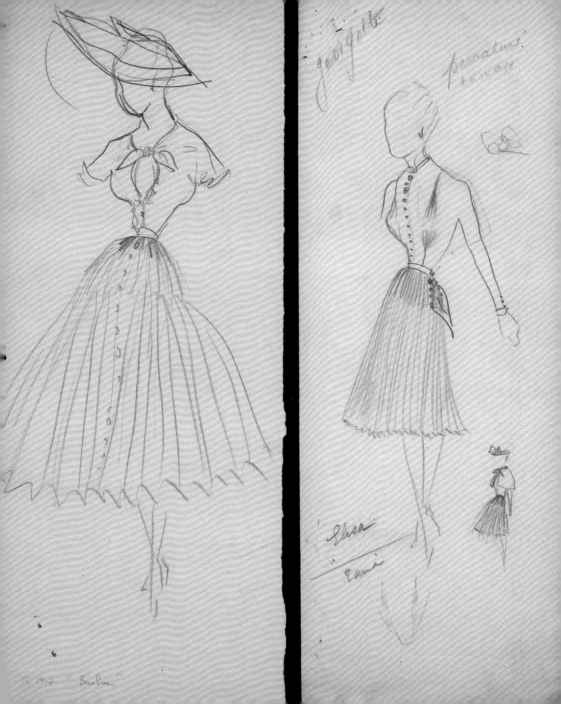

georgotte

permature
cervela

Elisa
Eané

1947 "Bonfarr"

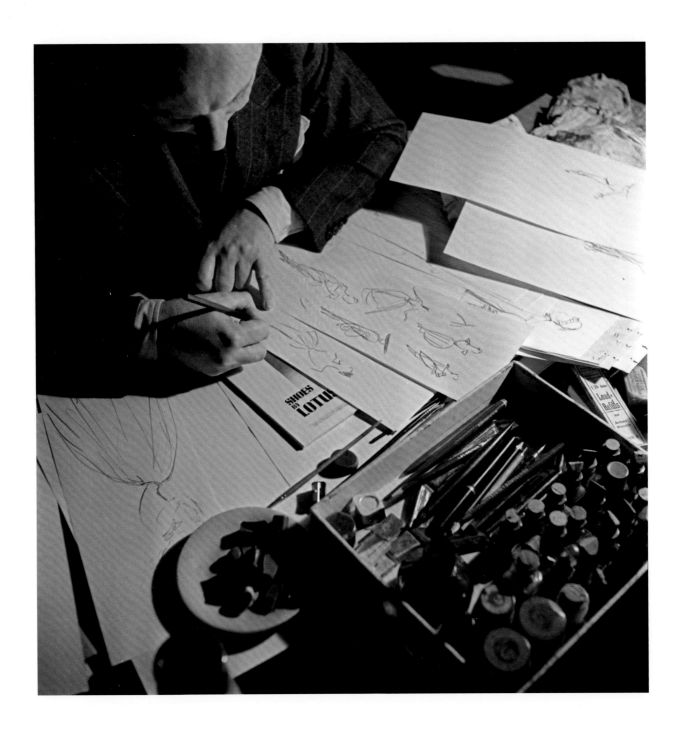

ABOVE Christian Dior sketching designs for a collection.
Photograph by Émile Savitry.

OPPOSITE Christian Dior's sketches for the *Bonheur* and *Corolle* dresses,
Spring-Summer 1947 Haute Couture collection, *Corolle* line.

ABOVE Last-minute preparations before the Autumn-Winter 1950
Haute Couture presentation. Photograph by Walter Carone.

OPPOSITE *Bar* suit jacket in natural shantung silk,
Spring-Summer 1947 Haute Couture collection.

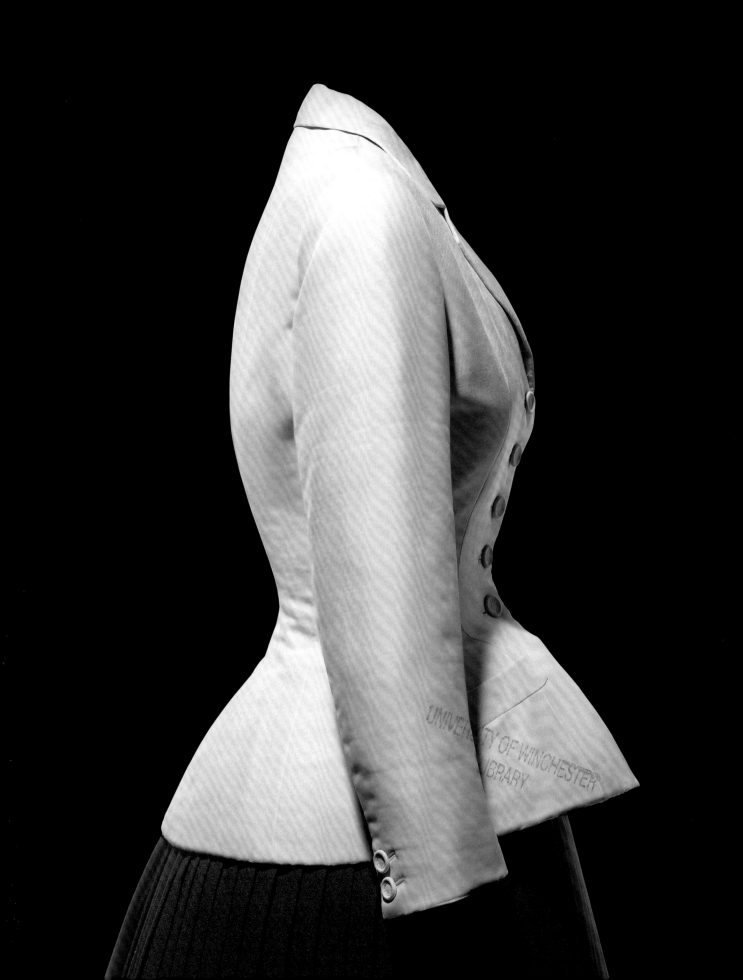

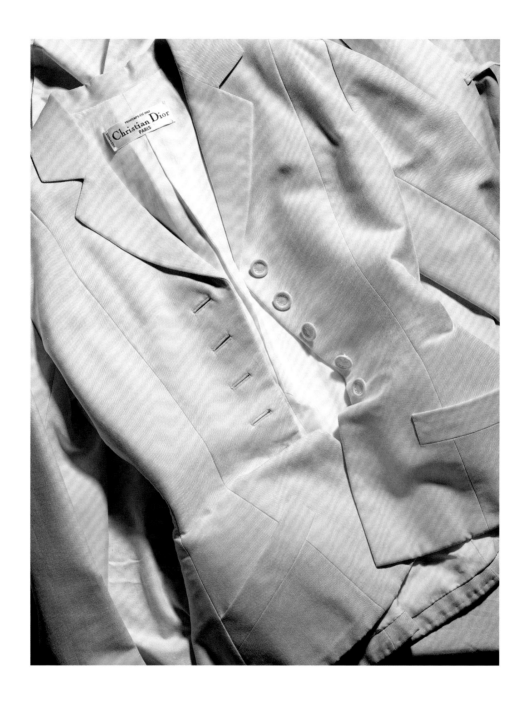

ABOVE *Bar* suit jacket in natural shantung silk,
Spring-Summer 1947 Haute Couture collection.

OPPOSITE The *Bar* suit jacket photographed by Patrick Demarchelier.

64

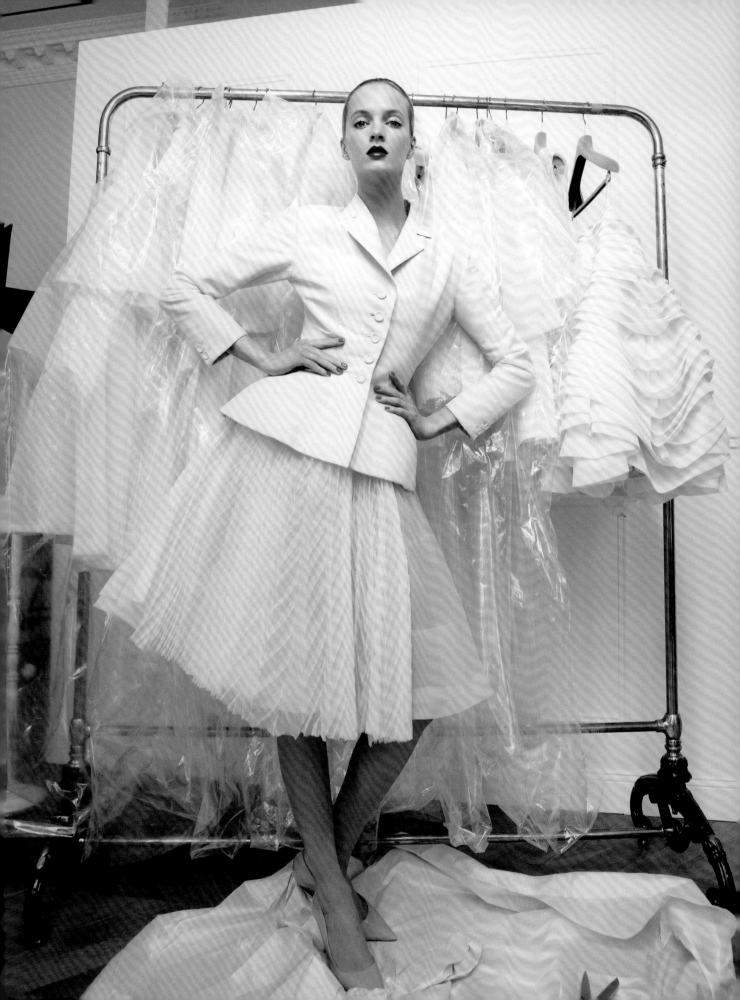

Christian Dior
by Pierre Cardin

Pierre Cardin was among the first employees recruited by Christian Dior, through an intermediary, Édouard Herriot, a member of the *Académie française*. "I began on November 17, 1946 at eight o'clock in the morning." At the age of ninety-three, the couturier has perfect recall of those moments spent in "that little house on avenue Montaigne, which still had a Cintra bar and a drugstore.... Monsieur Dior was a very erudite and discreet man of gourmet tastes. He didn't talk much, but he was very affectionate with his staff. One day, Monsieur Dior gave me a sketch, saying, 'I would like, young Pierre, for you to reproduce this for me.'" It was the *Bar* suit. At lunchtime the young designer, then aged twenty-one, decided to go and buy some cotton wool pads to round out gently the skirt of the ivory shantung jacket. "Tania was all skin and bones and we needed something to maintain the volume." Pierre Cardin remembers February 12, 1947 as though it were yesterday, smiling happily as he recalls the tiny fitting room with no space to pick up a dropped pin, where he dressed the models with Marguerite Carré. "It was the design that garnered the most applause."

In his office, Cardin still has two books given to him by Christian Dior, souvenirs of his three-year apprenticeship with the man he calls his "master." They are dedicated to "My dear Pierre, a colleague from day one." Time has not eroded his convictions. "The *Bar* suit was a symbol and a provocation. Where previously all had been lifeless, Christian Dior imposed a line. Without him, I would not have become Cardin."

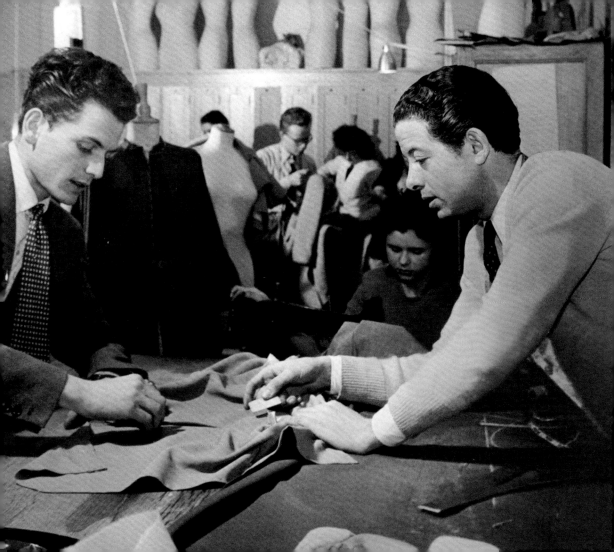

Raf Simons adjusting a suit from the Spring-Summer 2014 Haute Couture collection.
Photograph by Sophie Carre.

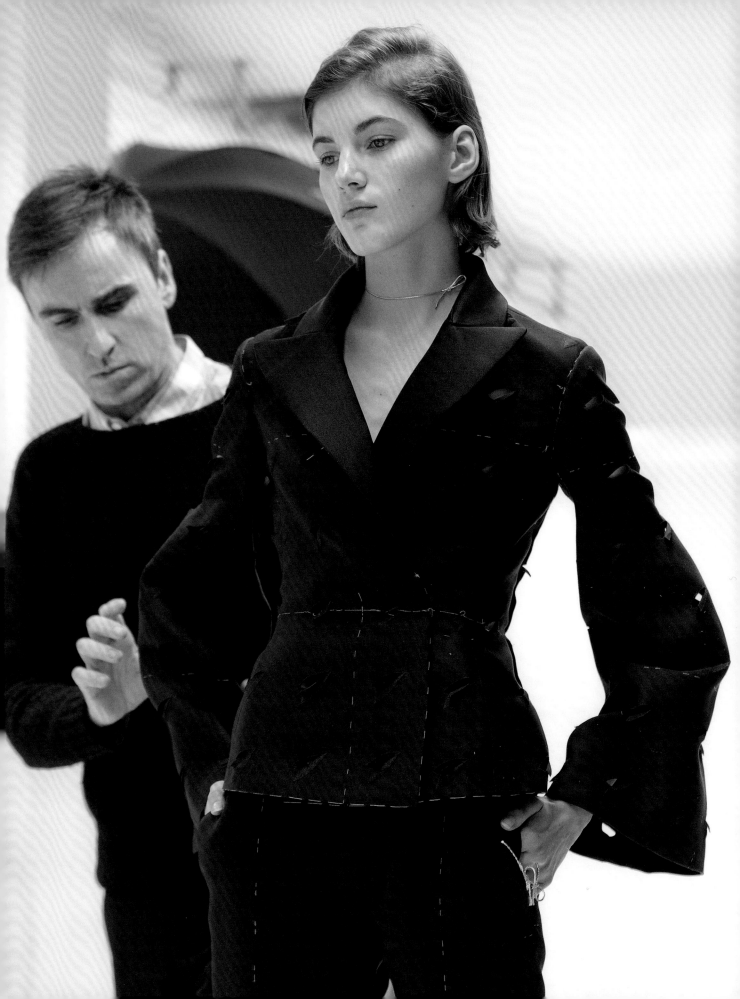

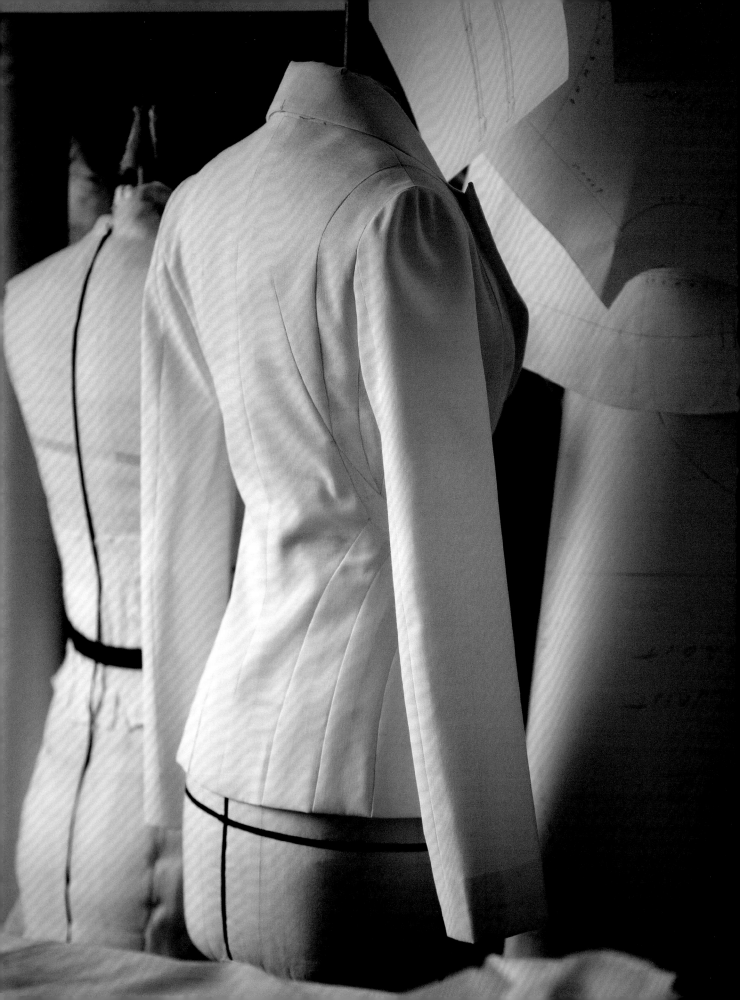

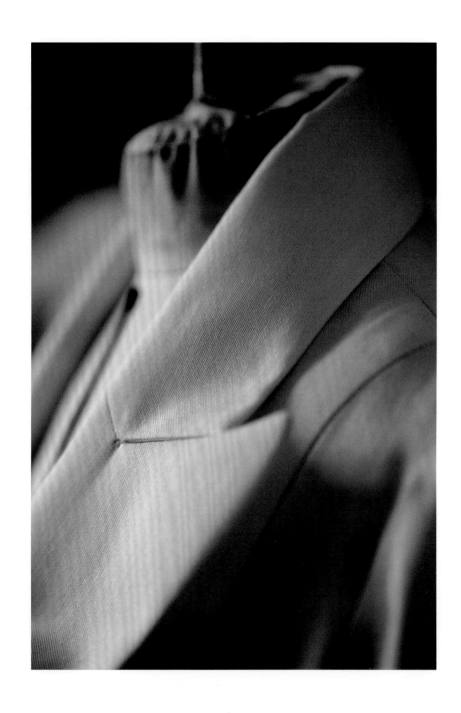

ABOVE AND OPPOSITE A jacket toile in the house of Dior ateliers,
Spring-Summer 2013 Haute Couture collection. Photographs by Sophie Carre.

A jacket toile from the Autumn-Winter 2012 Haute Couture collection.

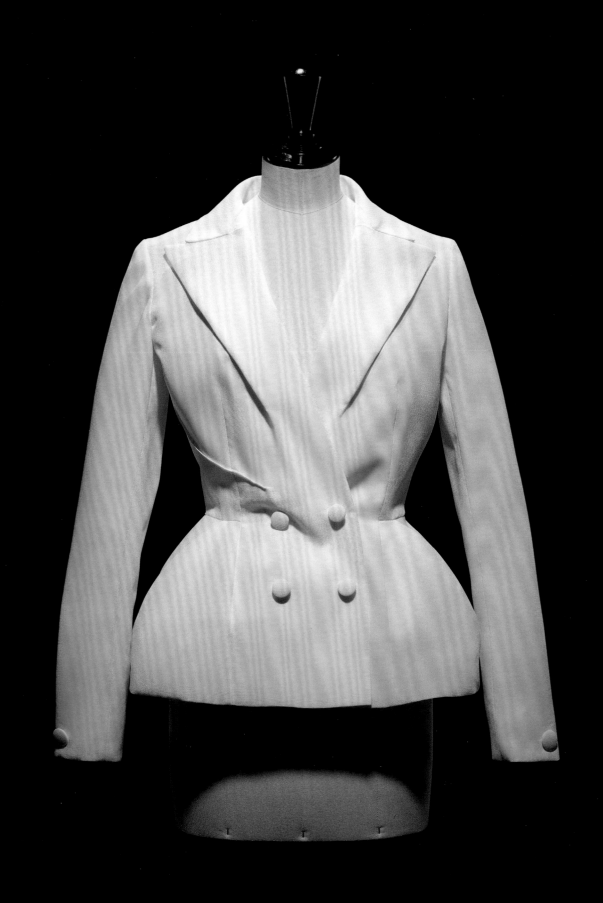

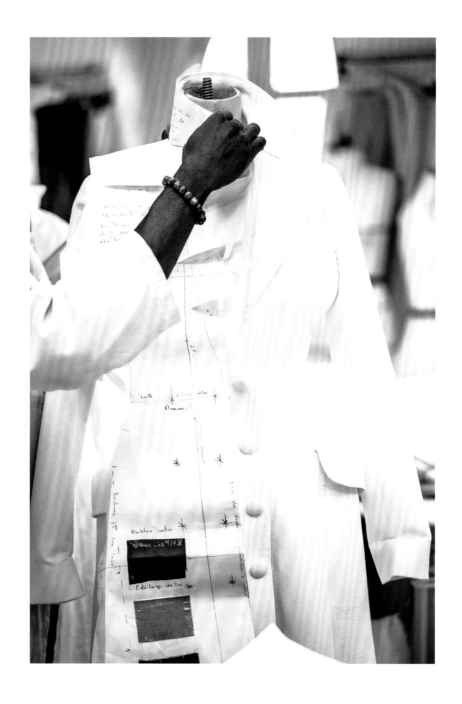

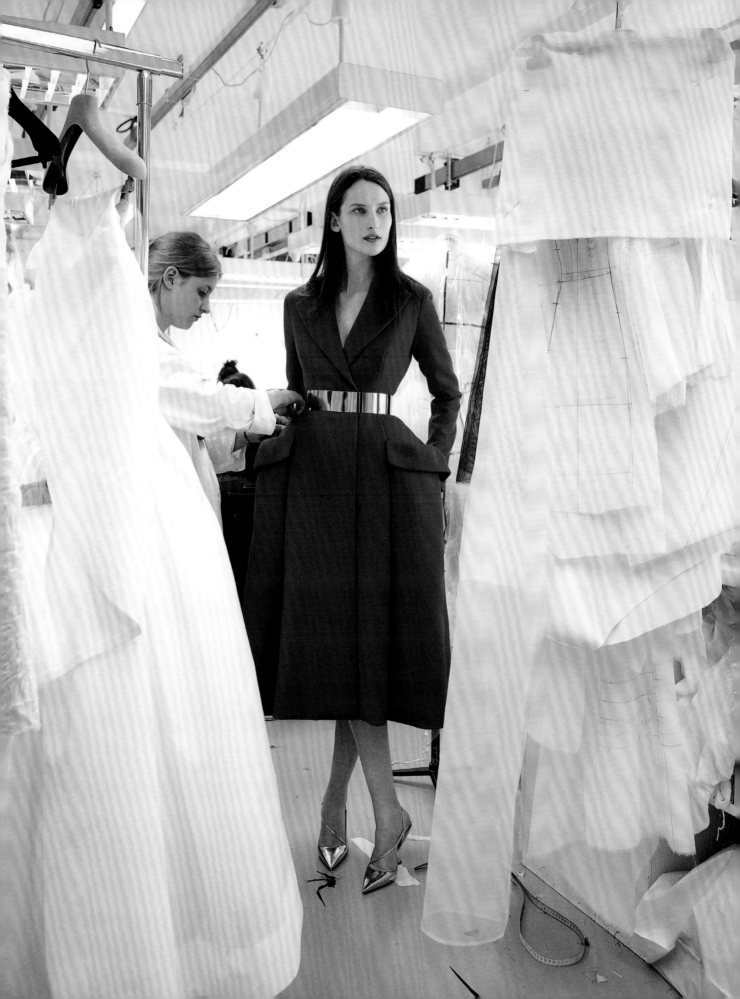

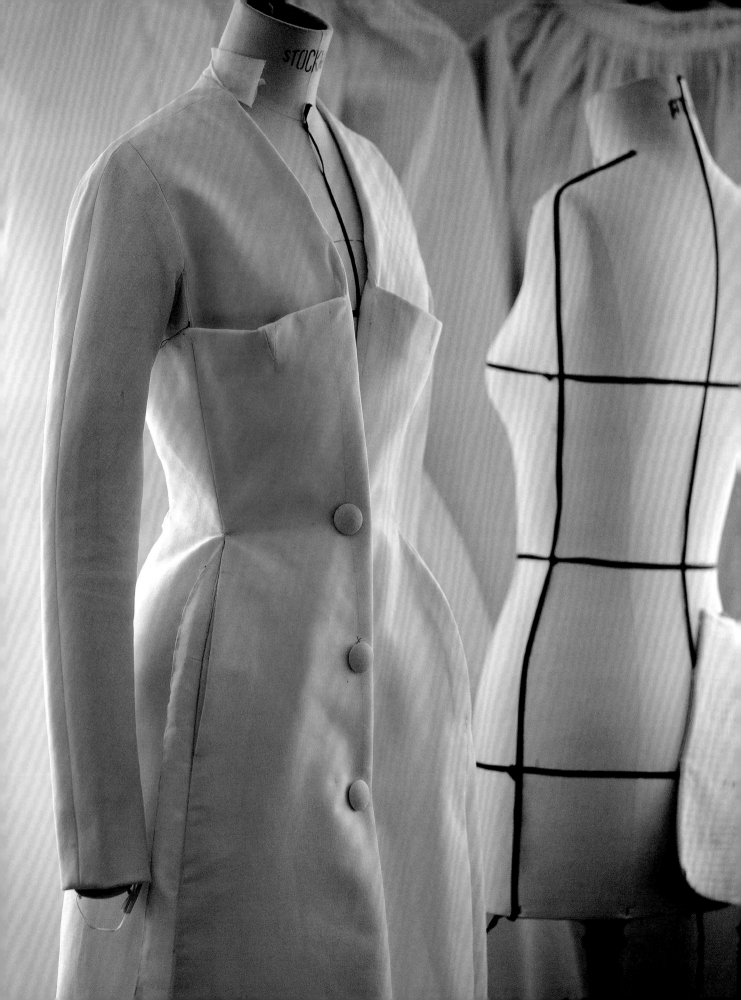

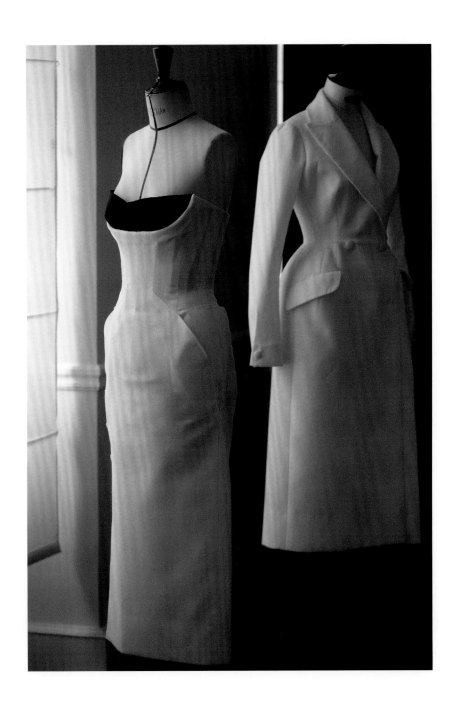

ABOVE AND OPPOSITE Toiles from the Autumn-Winter 2012 Haute Couture collection.
Photographs by Sophie Carre.

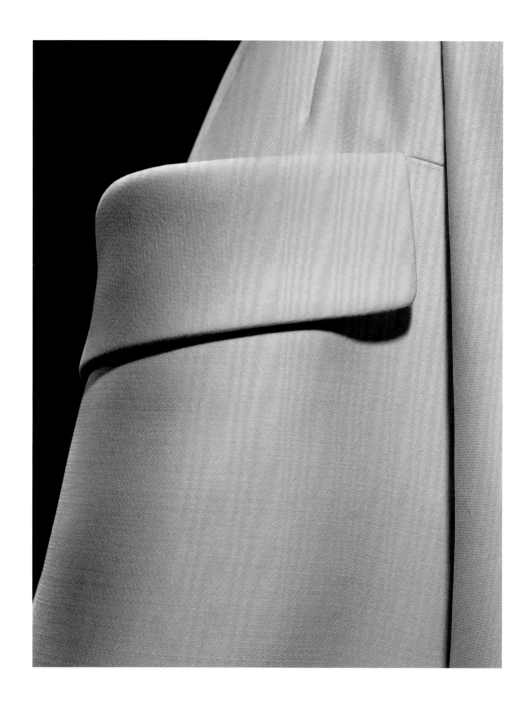

OPPOSITE Toile for a day dress in pale pink wool crepe with a structured bustier inset,
Autumn-Winter 2012 Haute Couture collection.

ABOVE Pocket of the same dress in pale pink wool crepe.

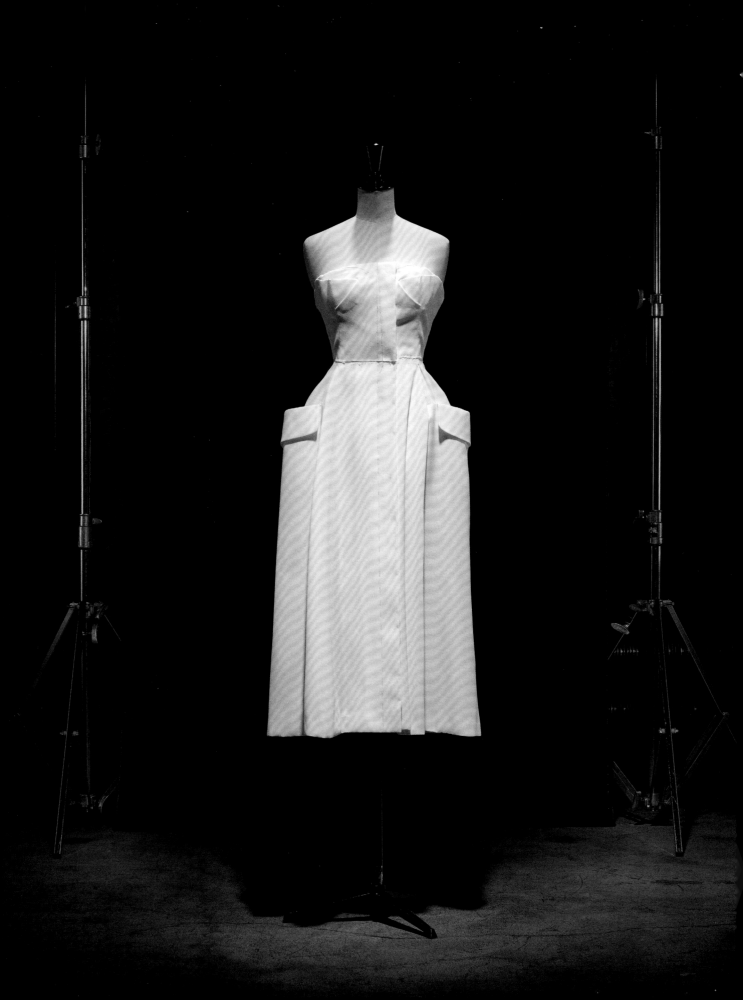

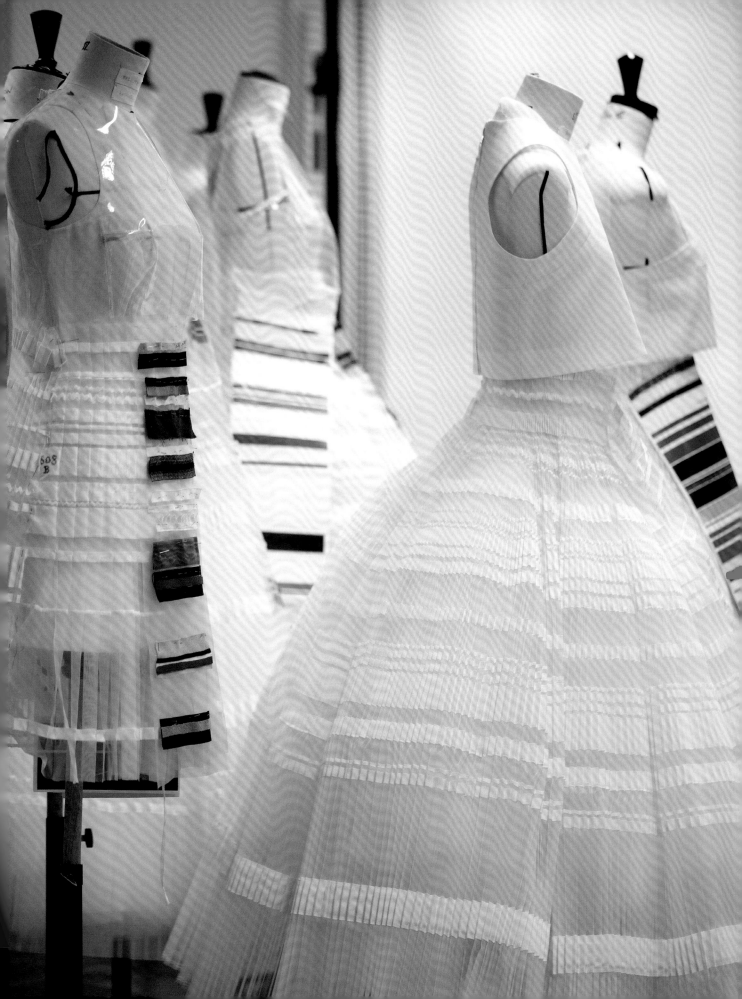

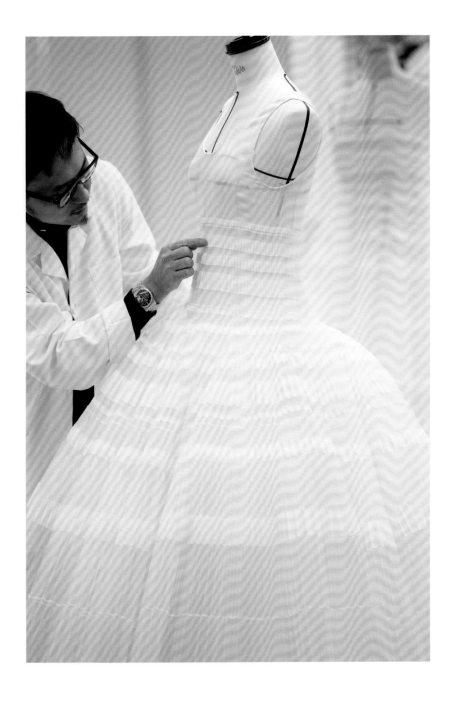

ABOVE Preparing a dress from the Spring-Summer 2015 Haute Couture collection.
Photograph by Sophie Carre.

OPPOSITE AND FOLLOWING PAGES In the house of Dior ateliers,
dresses from the Spring-Summer 2015 Haute Couture collection.
Photographs by Sophie Carre.

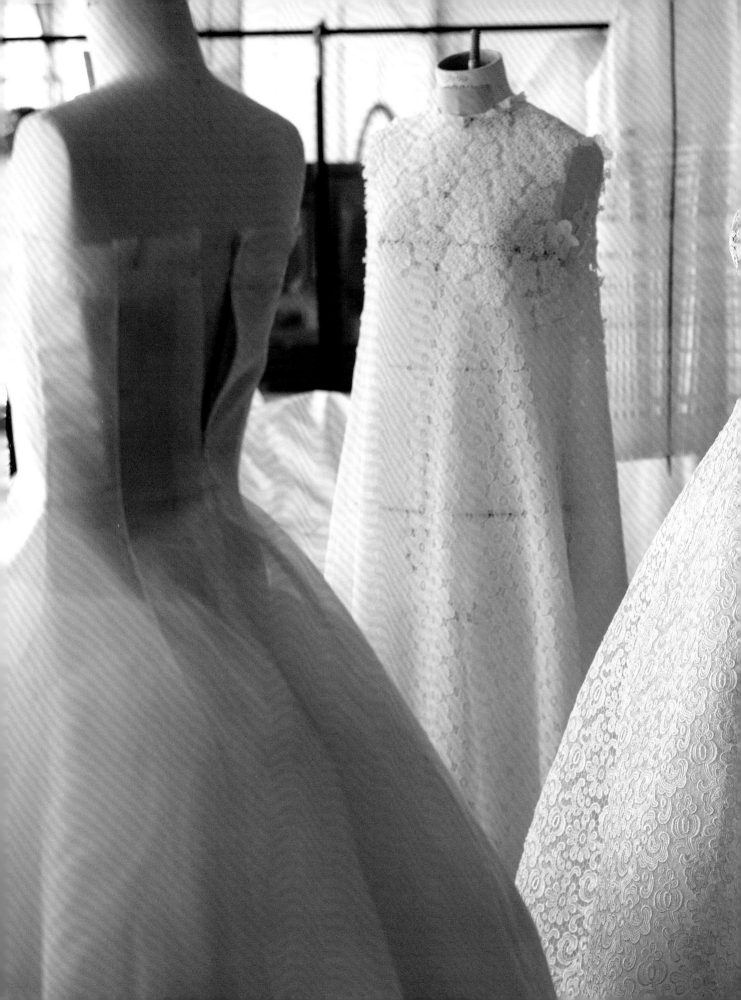

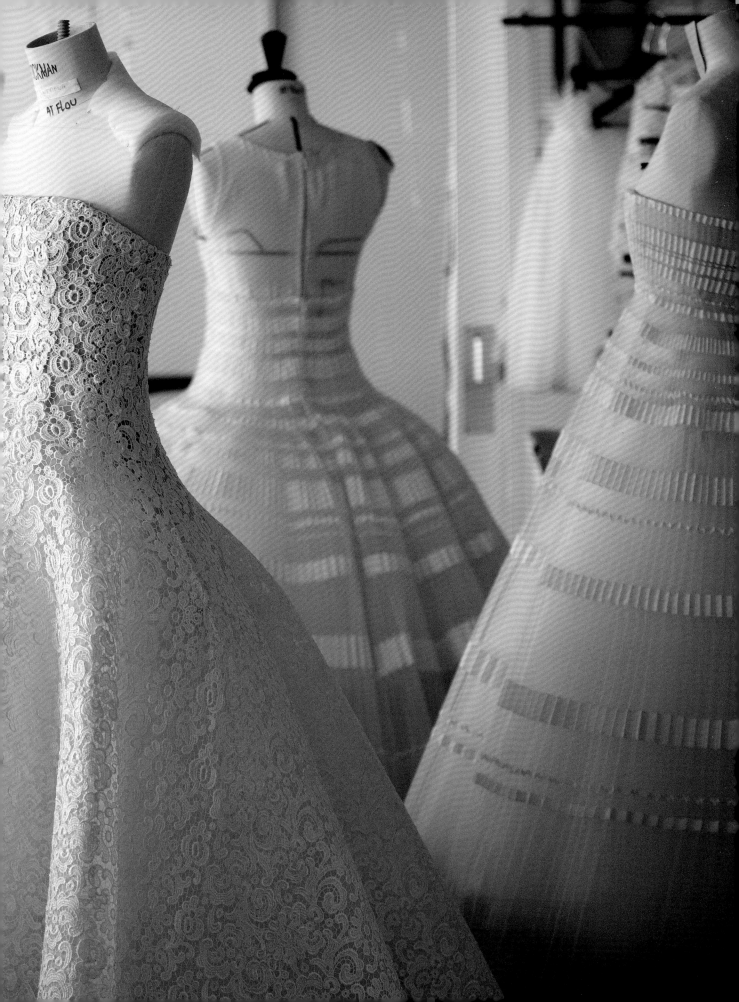

III

THE ESSENCE OF
A STYLE, HOMAGE,
AND CONTINUITY

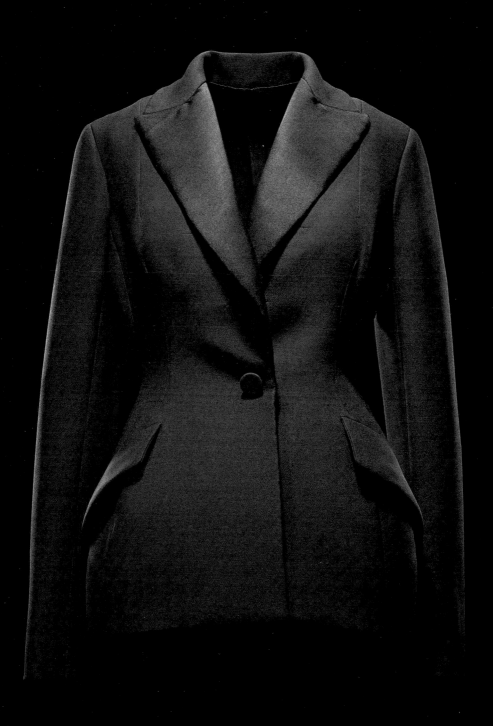

Codes and Interpretations

Although representative of prosperity for the Chinese, and of abundance for the Japanese, the numeral 8, symbolic of all creation and movement, returned to its primary meaning with Christian Dior. The number chosen by the couturier to define one of the two lines presented on February 12, 1947, marked not only a starting point, but also a promise of infinity. The *Bar* suit, which was part of the *Corolle* line, likewise opened a compendium of endless possibilities. It was a matrix in the Latin sense of the word, derived from *mater*, signifying "mother," that is, an element supplying support or structure that serves to surround, reproduce, and construct.

The Autumn-Winter 1947 collection would see the line sharpened further with new, "short-skirted jackets," emblematic of the "soft shoulders," "narrow waists," and "curved hips" that shaped the *Corolle* silhouette. For Christian Dior, who renewed the lexis of appearance every season, the recurrence of the "longer-skirted fitted jacket" (Spring-Summer 1948 *Zig-Zag* line), of the "well-defined waist" that "looked natural and fluid" (Autumn-Winter 1948 *Ailée* line), and the "fitted" suits with "neat waists" (Spring-Summer 1950 *Verticale* line) revealed an obsession that a taste for change could not erase. "The cut emphasizes the natural curve of the hips," read the program for the Spring-Summer 1951 *Naturelle* line.

It was all about the jacket again for Autumn-Winter 1951 (the *Longue* line), for Spring-Summer 1952 (the *Sinueuse* line), and for the following Autumn-Winter with the *Profilée* line, which molded the hips in clean, exquisite fabrics in a very tailored, and therefore very Dior, alternative "with a vague floating softness." Therein lay the motto that set the story in motion: "Avoid a thickening of the waist." Christian Dior was a veritable surgeon of style, showing in a rather visionary manner that the youthfulness of a style is linked to a slender figure and to physical discipline, which he himself rejected.

History often loses sight of the modern element in Christian Dior's designs, placing him in the nostalgia corner, when in fact he was all about expressing infinite gratitude to a universe filled with small miracles, such as the beauty of women, *joie de vivre*, "well-composed landscapes and the glimmering silken heavens," cherished by

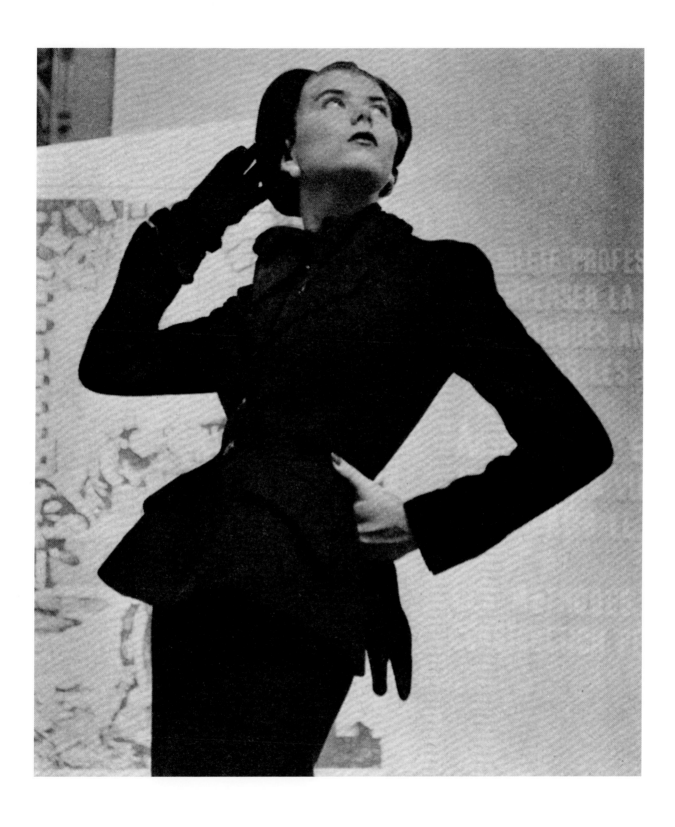

PREVIOUS PAGE Black wool tuxedo "Bar" jacket, Autumn-Winter 2012 Haute Couture collection.

ABOVE Suit from the Autumn-Winter 1947 Haute Couture collection, *Corolle* line.
Photograph by Horst P. Horst.

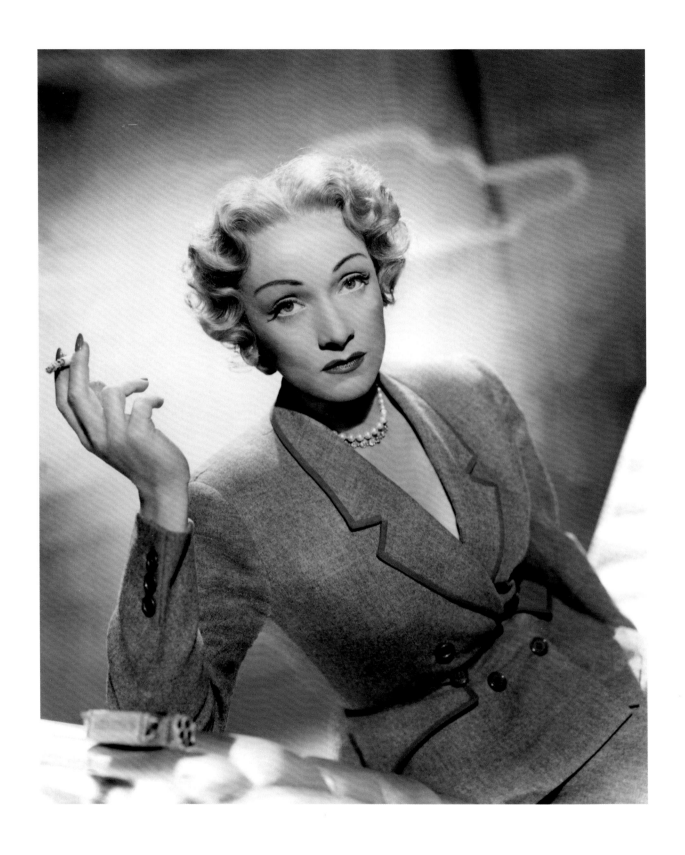

Marlene Dietrich in Alfred Hitchcock's *Stage Fright* (1950),
wearing the *Acacia* suit, Spring-Summer 1949 Haute Couture collection.

the painter Paul César Helleu, whose work the couturier appreciated. For Christian Dior, a well-defined waist indicated youth. He saw it as an ideal marker revealing nature at its most beautiful, and he never tired of drawing on it. "A beautiful waist is a light and fluid arc, rounding and curving in a charming valley that rises to the hips with a gentle slope."[1]

Even with the *Y* line (Autumn-Winter 1955), with its "slender, more than snug waist," or the *Flèche* line (Spring-Summer 1956), whose suits "caressed a high waist," the narrow waist obsession remained a fixture and became the recurring element par excellence of the Dior spirit. To the very end, with the "gently cinched waists" of the *Libre* line (Spring-Summer 1957), the *Bar* recurred like Christian Dior's bent note, becoming the stylistic element with which he gradually and expressively told the story of his life. The structure of the *Bar* is not dissimilar to that of an hourglass: time runs away like a spiroid river around an immobile center that is eternally present, physically represented by the female waist—that golden ring, that magic circle. It is an absolute primordial symbol that represents the finite and the infinite, the single and the multiple, the whole and perfection.

"To slim down the body without losing the waist" was the couturier's ultimate goal, and the *Bar* suit was a perfect balance of harmonious curves and lines, where ideal proportions embodied a natural promise of happiness. "My models are the life in my dresses, and I want my dresses to be happy," Dior declared.

Indeed, beyond fashion moments he knew to be ephemeral, he established the memory of what came before him and the future to which he would remain loyal: "A well-formed body rises from a narrow waist, with an emphasized bust, rounded hips under voluminous skirts, slender shoulders, hidden calves, and a neat head. This was fashion according to Dior, in all its soft curves, resurrecting femininity."[2] A fashion historian, Christian Dior carved out his career at the heart of a world whose protagonists he defined majestically, as seen in his conference at the Sorbonne in 1955: "Paul Poiret came along and overturned everything. In contrast to the polished outfits of the day, he created spirited designs that arose from astonishing color and his felicitous scissor work. After him, Madeleine Vionnet, Jeanne Lanvin, and Mademoiselle Chanel definitively affirmed that the cut was of paramount importance." He continued, "It was a revolution with extensive consequences that led us precisely to where we are now. If a couturier is capable of talking to you of his job today, it is because his profession has moved from craftsmanship to artistic creation. It is because he designs dresses and seeks to impose his own tastes. Fabric, which was once the primordial element, now bows down to style."

With the *Bar* suit, Christian Dior shaped an attitude and a manner of seeing things that he expressed again and again in his programs, in which the words map out a leitmotif: "A lithe, full bust combines with an extremely rigorous cut that leaves nothing to chance" (Spring-Summer 1952, *Tulipe* line). With the *Vivante* line (Autumn-Winter 1953), the jackets were "glued to the hips." In the "farewell to the *Princesse* line" of Spring-Summer 1954 (*Muguet* line), as in the "accentuated hips" of the *H* line (Autumn-Winter 1954), or the "lengthened bust" of the *A* line (Spring-Summer 1955), the traits of the *Bar* appeared in subliminal fashion.

It was truly the rigorous nature of the cut that characterized "Bar" after *Bar*, which became the gold standard of an unparalleled success. "Behind all the frills, the figures speak and judge," said Christian Dior. The genuine international phenomenon engendered by the New Look would be reinforced by tributes and celebrations, starting with the great Christian Dior exhibition that opened at the Musée des Arts de la Mode in Paris on March 21, 1987. "We wanted to lengthen hemlines, but Dior went further with his New Look collection by opting for volume, too. What made the silhouette novel was its pronounced waist and in particular, the removal of the padding, which wasn't exaggerated like today, yet was nevertheless still very distinct," analyzes Marc Bohan, artistic director of the house of Christian Dior from 1961 to 1989. "Dior fashion had a charm of its own. It was unfailingly very feminine."

When Gianfranco Ferré took over in 1989, he noted that "Christian Dior had created a more feminine silhouette, revealing shoulders, emphasizing the bust, rounding out the hips, and accentuating the waist. He did not hesitate to overturn the proportions of the body to render it more graceful. And he took everyone by surprise when he placed the hemline below the knee. It was the great New Look boom."[3] In 1989, Ferré was awarded the Dé d'or, the highest distinction in haute couture, for his first Dior collection, entitled *Ascot-Cecil Beaton*. Although the *Bar* suit metamorphosed into a belted organza dress christened *Forcément* (Spring-Summer 1991 Haute Couture collection), the "identifying signs" were especially evident in the Spring-Summer 1995 Haute Couture collection and the Spring-Summer 1996 Prêt-à-Porter collection. "A redefined silhouette wherein cut is essential in the desire to mold the body and to shape it in the closest possible fit without hindrance" (French *Vogue*, February 1995). "Androgyny is over, and curves are back in fashion… a new feminine body is gradually taking shape" (*Le Nouvel Observateur*, February-March 1995). For Spring-Summer 1996, the "Bar" jacket, created in smooth satin with pockets embroidered in gold sequins, was worn with an immaculate long taffeta skirt.

The arrival of John Galliano at Dior in 1996 marked a new era that saw codes reinterpreted and divided into three main areas: day, lunch, and travel; late afternoon,

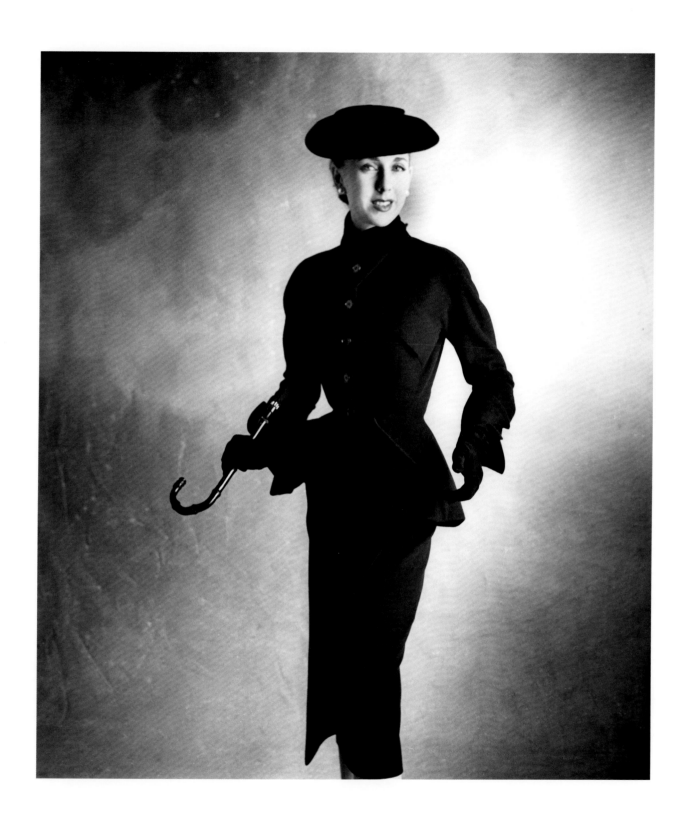

Model Tania wearing a suit from the Autumn-Winter 1950
Haute Couture collection, *Oblique* line. Photograph by Irving Penn.

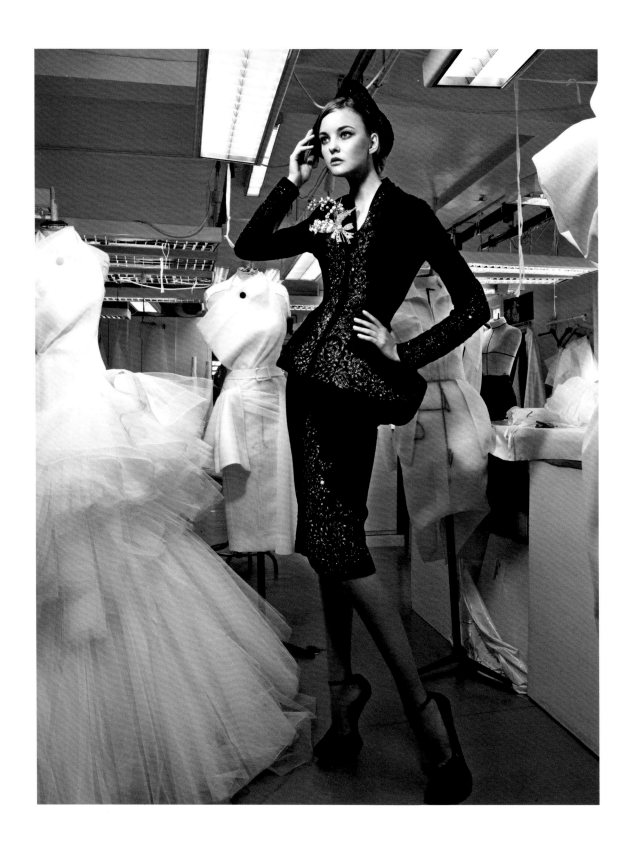

Gisele Bündchen Inspired by Irving Penn suit, Autumn-Winter 2007
Haute Couture collection. Photograph by Patrick Demarchelier.

cocktails, and dinner; and evening, evening events, and balls. A subliminal reference to the *Bar* suit was contained in the *Diorbella* design, in black mini-hound's-tooth check wool, worn with a "short *A*-line skirt." It was seen again in the *Galliador*, whose jacket was finely worked in white leather embroidered lace, and particularly the *Diosera*, an ensemble with a fitted jacket of ivory wool crepe. Narrow kimono sleeves, padded hips, and fringed hems completed the appearance of a black crocodile mini-skirt and a "bone-textured" dog collar. Six months later in the Bagatelle gardens, the *Bar* suit embarked on a neo-colonial voyage with African princesses whose slender waists echoed the Masai necklaces they wore at their necks.

At the presentation of the Spring-Summer and Autumn-Winter 1997 Haute Couture collections, the *Bar* line, "emblematic of Dior and reconstructed with a silhouette of the fitted jacket that curved outward at the hips, was still the favorite." It had narrow shoulders, glove sleeves, and the Dior pocket "with its seamless flap," along with "very sharp, very deep-cut" suit lapels on a jacket that stood away from the hips. It thereby accentuated an ultra-feminine silhouette that appeared for daywear in "very austere wools, borrowed from the male wardrobe in the continuity of Dior style." Although the garments were lighter and more fluid, the *Bar* signature lent itself to all textures, from the tailored to the fluid, with gossamer versions cinched in corselets. This approach appeared again for Spring-Summer 2009, which saw a black and white alternate with "classic Dior diaphanous drapes mischievously buttoned up," and structured cuts alternate with translucent shades of mousseline. The "Bar" belt in patent leather hung like a music note on a freely interpreted score, and no fewer than fourteen jackets were the shining stars of the collection. "A contemporary version of couture. A season filled with change that is all about cut and sophistication. A new, very sexy approach has entered the salons," declared John Galliano. Celadon green leather, leopard-print silk, and embroidered sky-blue silk: from the palest to the brightest, eye-shadow colors invaded the *Bar*'s color field, which had previously been limited to black and ivory.

From boudoir to boardroom, from bar party to a cappella concert… In 2012, the arrival of Raf Simons as artistic director of Christian Dior Haute Couture and Prêt-à-Porter collections marked a turning point. In breaking with an accumulation of post-modern references, he favored a return to the lexicon and pure lines freed from any historical reference and particularly encouraged the arrival of a streamlined femininity stripped of all artifice.

In every collection that was to follow the first, this contemporary liturgy excluded reference in favor of line. The lines of the black pant suit, the red coat, and the gray dress set an identity in motion. Accessories became touches of light—a gold belt, a

slash of red on the lips, or a pair of metallic silver leather shoes. From one collection to the next, the play on cut, honeycombed texture, woven highlighting, and color composition inspired by abstract art and the decorative arts of the 1950s to 1970s reinforced the graphic point of view. Theatrical references faded, making way for the most genetically structured style, as expressed in the manner of Mats Gustafson's watercolors of faceless women, recognizable anywhere, who are free, urban, and affirmed with the stroke of a brush. "We are bringing an extremely modern idea to life from a very historical base," explains Raf Simons, as he alternates between the eighteenth century and astronauts' uniforms. Whence the key stylistic intention to reveal the "Dior archives in their most abstract and geometric embodiments," as stated in the program for the Autumn-Winter 2014 Haute Couture collection: "Providence means looking both forward and backward to prepare for the future." Without posturing and in all simplicity comes the most naturally sincere tribute to Christian Dior, whose words, like his creations, have never resonated as well as they do in 2015: "In our era as in previous times, we are searching for our identity. The mirror that will show it to us can only be that of truth."

[1] "SAR la princesse Clémentine," in *Les Belles Femmes de Paris*, first edition, 1839, p. 103.
[2] Françoise Giroud and Sacha Van Dorssen, *Christian Dior*, Éditions du Regard, Paris, 2006.
[3] Gianfranco Ferré, *Lettres à un jeune couturier*, Balland, Paris, 1995.

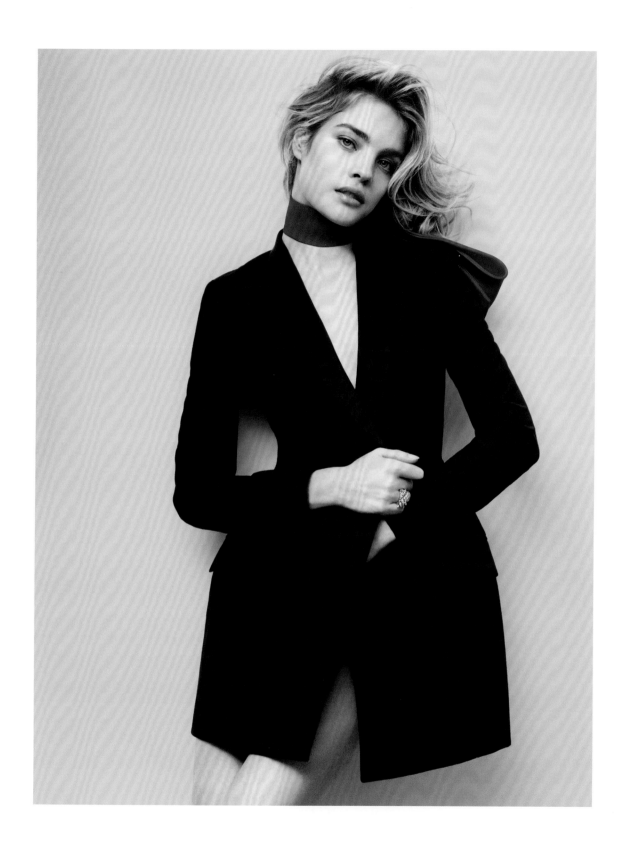

Natalia Vodianova wearing a "Bar" tuxedo coat-dress, Spring-Summer 2013
Prêt-à-Porter collection. Photograph by Paolo Roversi.

Cours la Reine ensemble in navy ottoman,
Spring-Summer 1948 Haute Couture collection, *Envol* line.

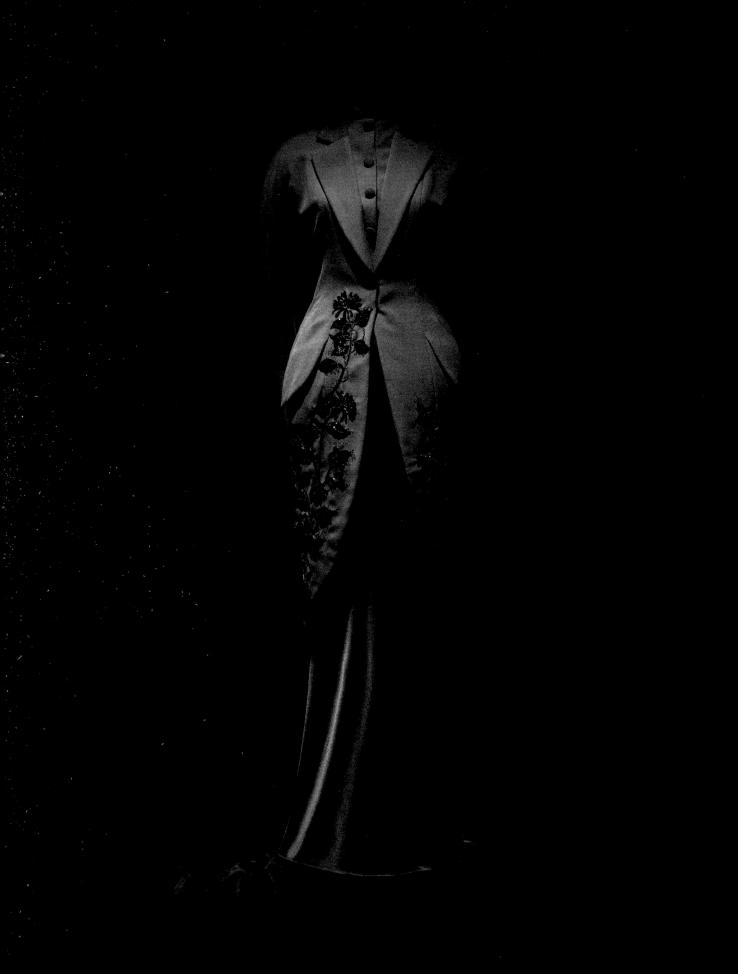

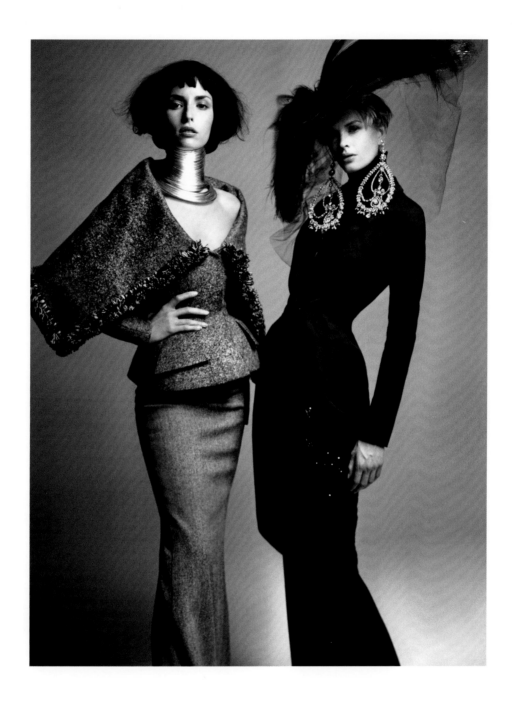

ABOVE *Princesse Bundi* and *Princesse Partabgarh* ensembles, Autumn-Winter 1997
Haute Couture collection. Photograph by Patrick Demarchelier.

OPPOSITE *Princesse Partabgarh* ensemble, a long and shapely coffee wool whipcord frock coat.

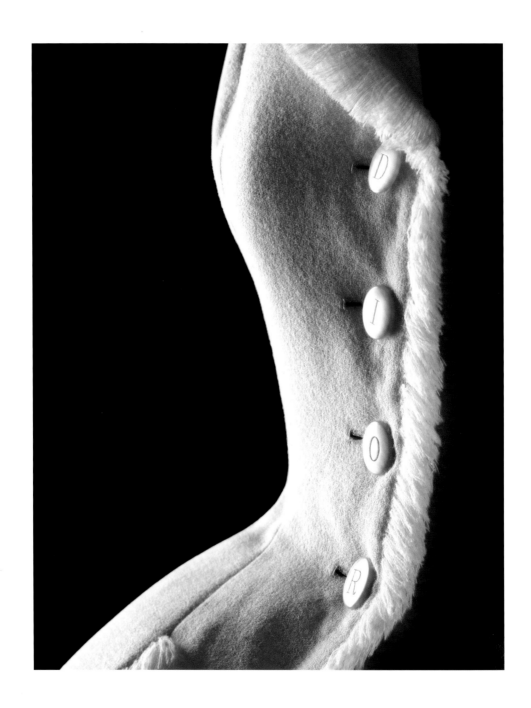

OPPOSITE *Diosera* ensemble, Spring-Summer 1997 Haute Couture collection.
Photograph by Patrick Demarchelier.

ABOVE Detail of the *Diosera* ensemble jacket, in ivory wool crepe.

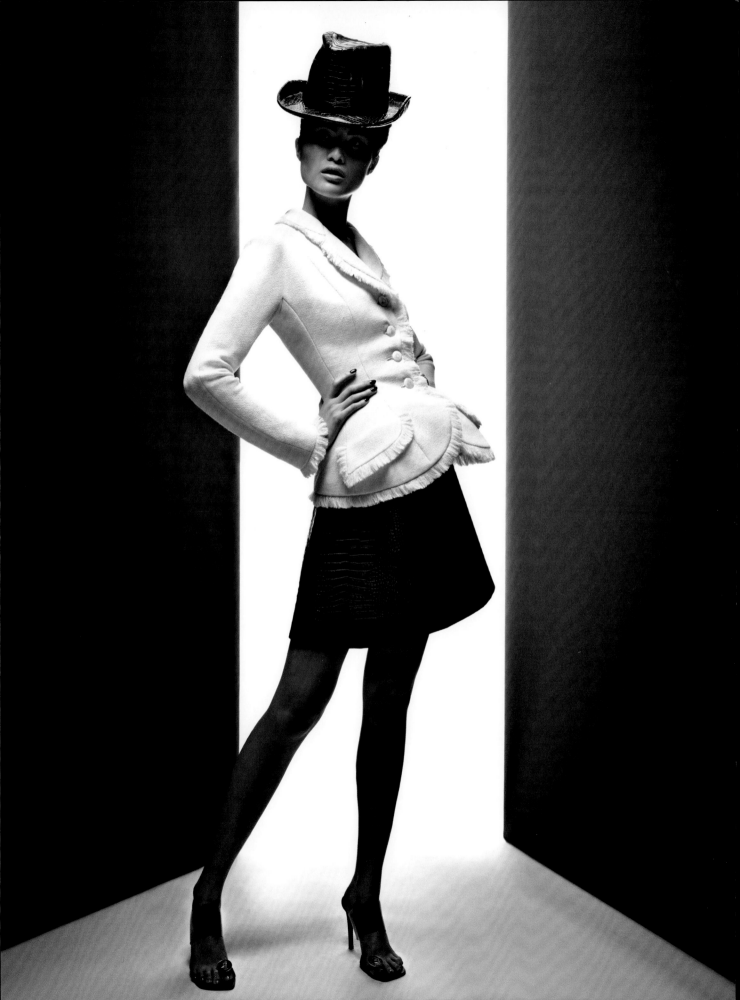

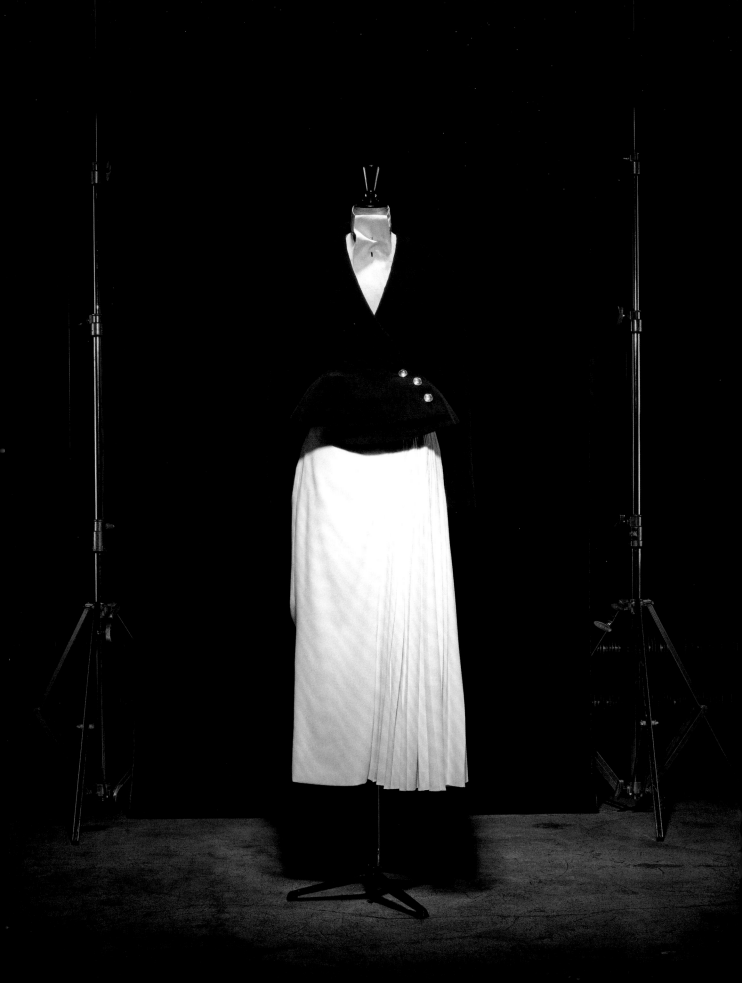

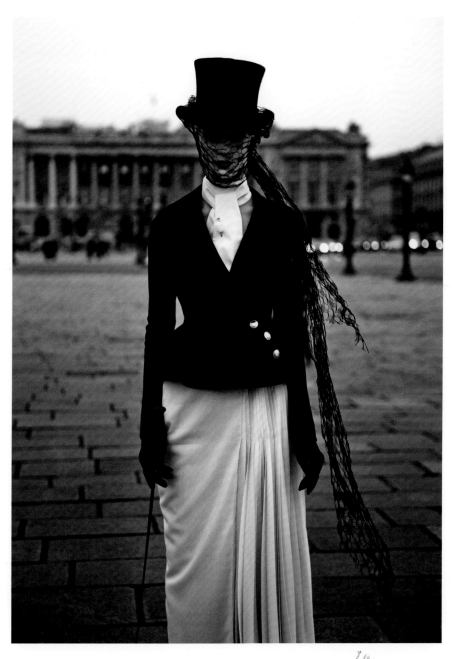

OPPOSITE Black wool jacket and off-white wool skirt ensemble,
Spring-Summer 2010 Haute Couture collection.

ABOVE The same ensemble photographed by Patrick Demarchelier.

103

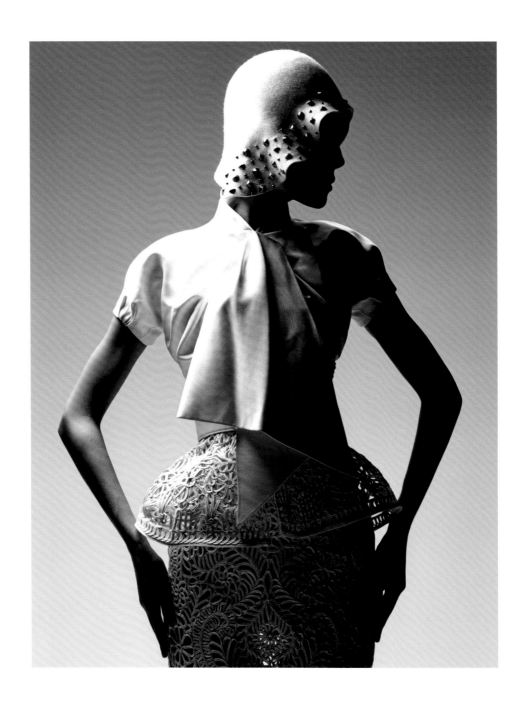

ABOVE Embroidered off-white silk jacket and off-white silk skirt, Autumn-Winter 2008
Haute Couture collection. Photograph by Patrick Demarchelier.

OPPOSITE Black wool and silk dégradé jacket and black silk skirt,
Autumn-Winter 2008 Haute Couture collection.

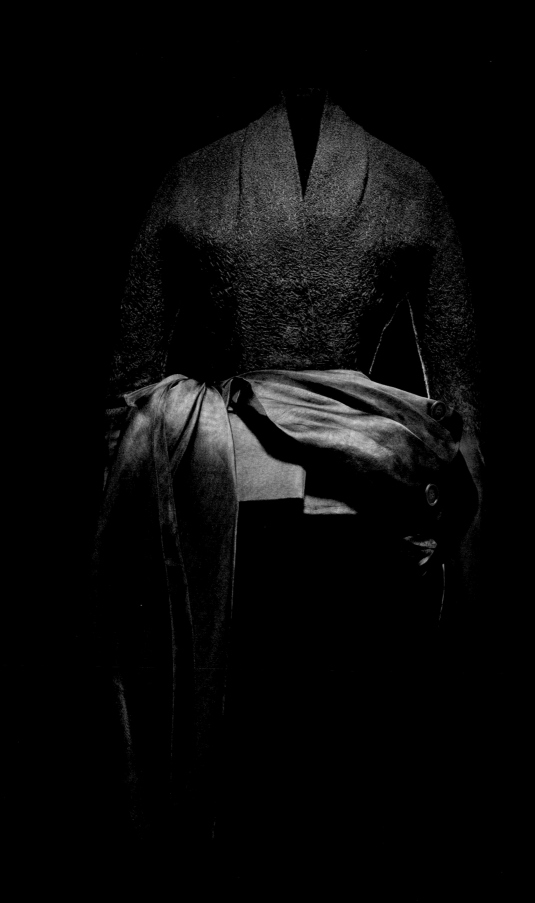

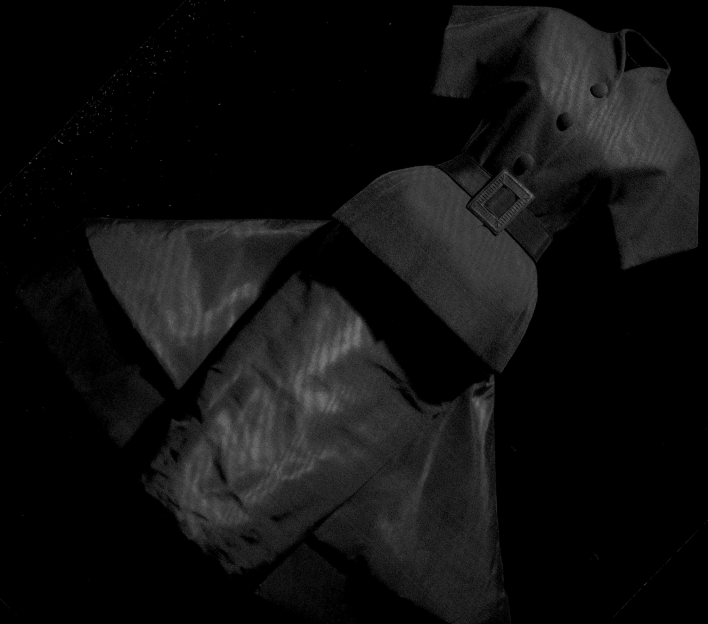

ABOVE AND OPPOSITE Red silk and wool dress,
Spring-Summer 2009 Haute Couture collection.

Embroidered fuchsia wool crepe jacket,
Autumn-Winter 2009 Haute Couture collection.

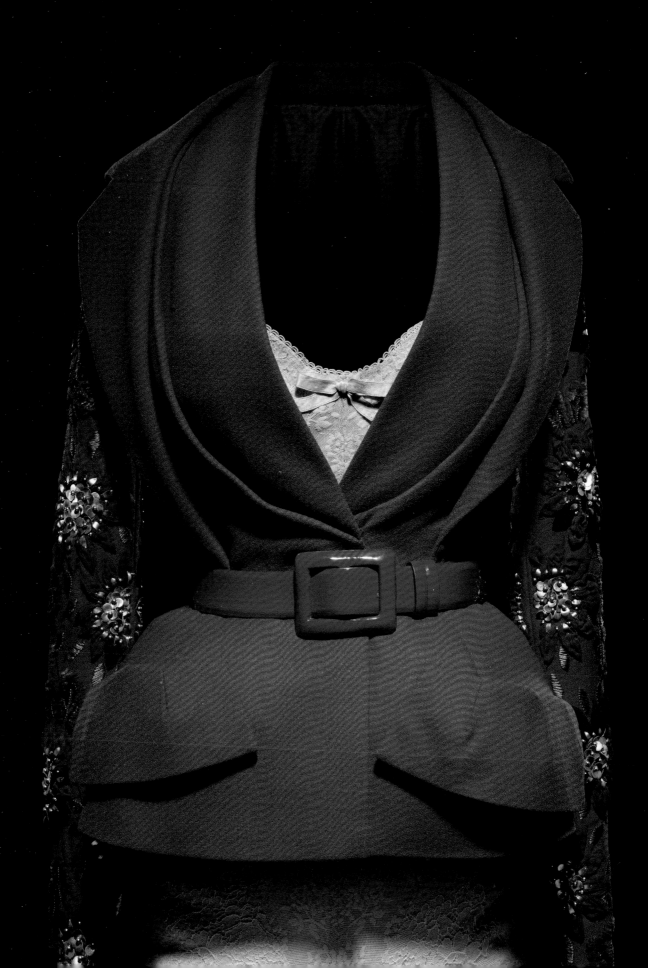

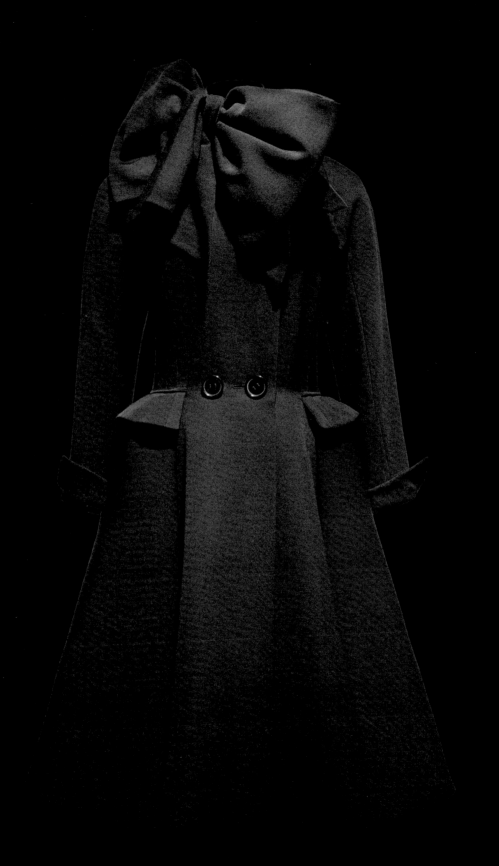

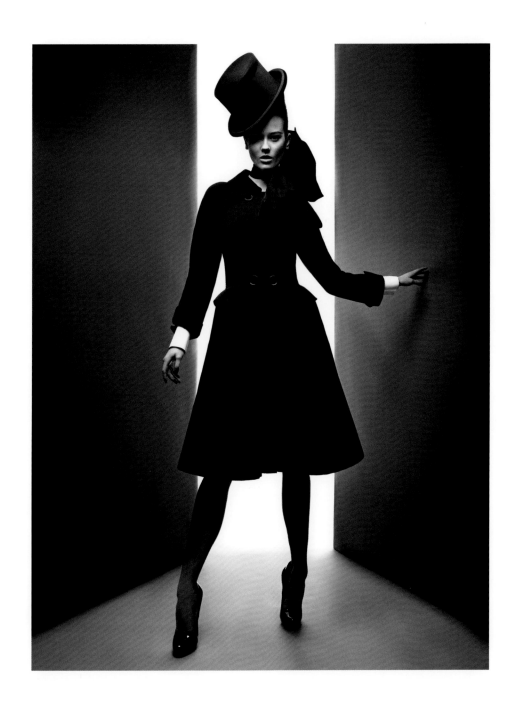

OPPOSITE *Cecil* redingote in black barathea,
Autumn-Winter 1989 Haute Couture collection.

ABOVE The *Cecil* redingote photographed by Patrick Demarchelier.

111

Off-white silk jacket and black silk skirt,
Spring-Summer 2009 Haute Couture collection.

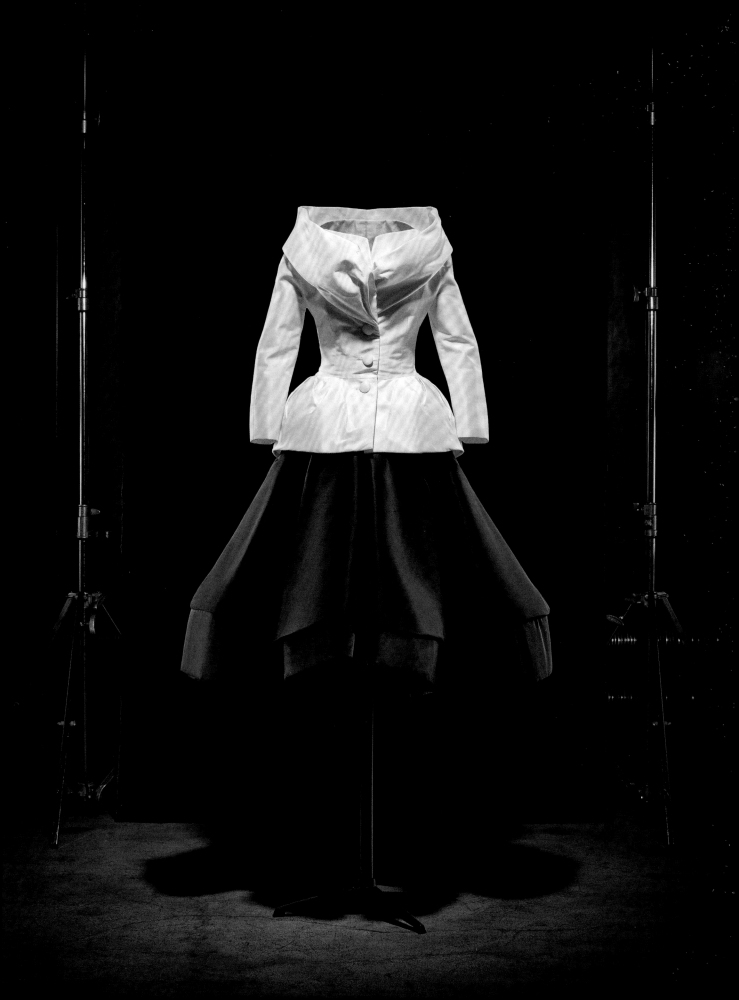

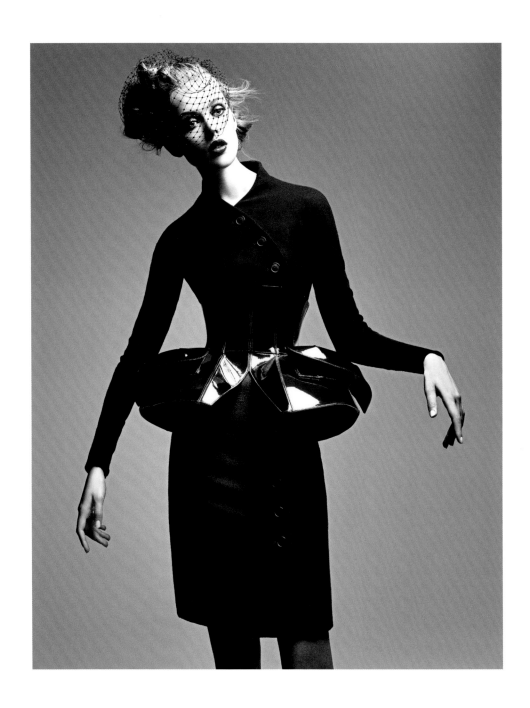

ABOVE Black wool dress worn with a black patent leather "Bar" belt,
Autumn-Winter 2008 Haute Couture collection. Photograph by Patrick Demarchelier.

OPPOSITE Cream wool coat worn with a black patent leather "Bar" belt,
Autumn-Winter 2008 Haute Couture collection.

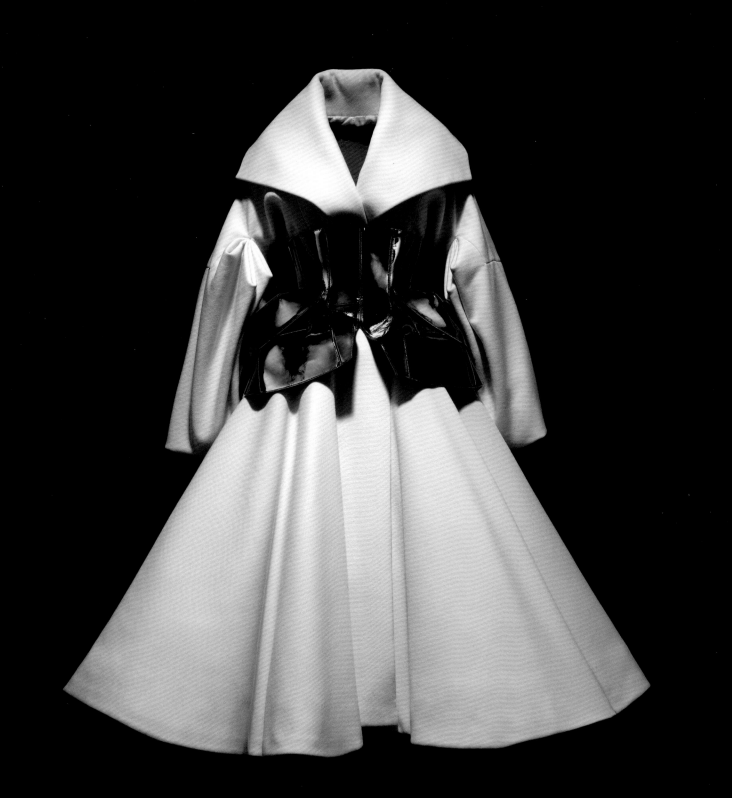

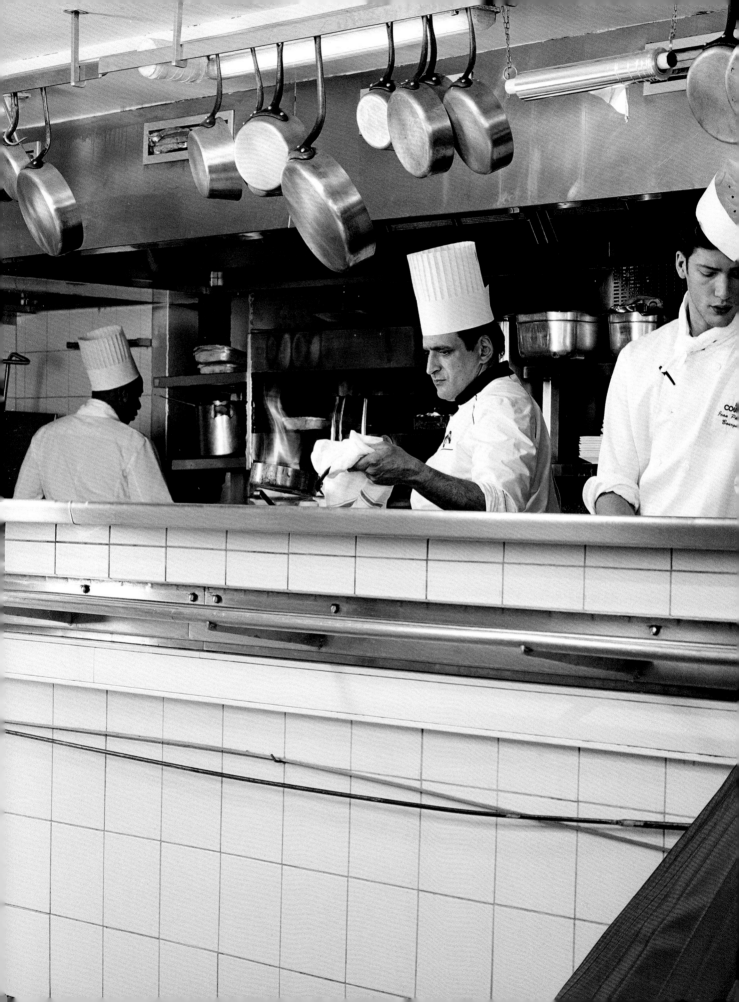

PREVIOUS PAGES Embroidered off-white silk and black dégradé tulle jacket and red silk skirt,
Spring-Summer 2011 Haute Couture collection. Photograph by Miles Aldridge.

OPPOSITE Red wool dress, Spring-Summer 2010 Haute Couture collection.

ABOVE The same dress photographed by Patrick Demarchelier.

Pleated red silk evening gown, Autumn-Winter 2013 Haute Couture collection.
Photograph by Patrick Demarchelier.

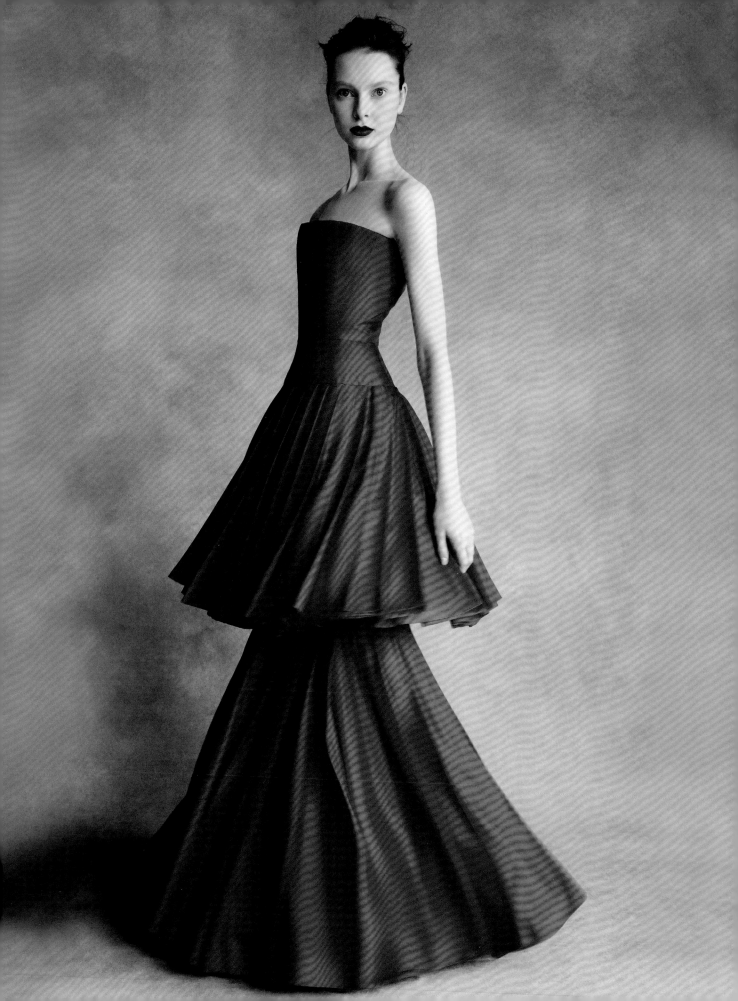

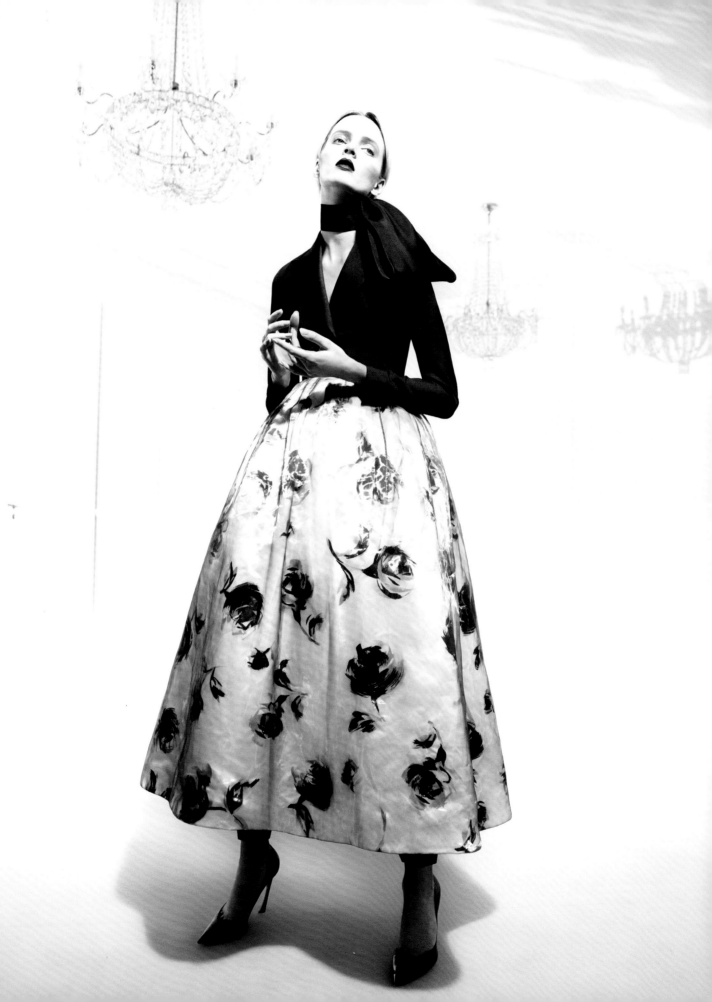

ABOVE Mats Gustafson illustration of an ensemble from the
Spring-Summer 2013 Prêt-à-Porter collection.

OPPOSITE White and pink printed satin duchesse and blue metallic silk skirt worn
with a black silk/cashmere knitted top, Spring-Summer 2013 Prêt-à-Porter collection.
Photograph by Willy Vanderperre.

ABOVE Mats Gustafson illustration of a dress from the
Spring-Summer 2014 Prêt-à-Porter collection.

OPPOSITE Natalie Portman wearing a "Bar" pant suit from the
Spring-Summer 2014 Prêt-à-Porter collection.
Photograph by Paolo Roversi.

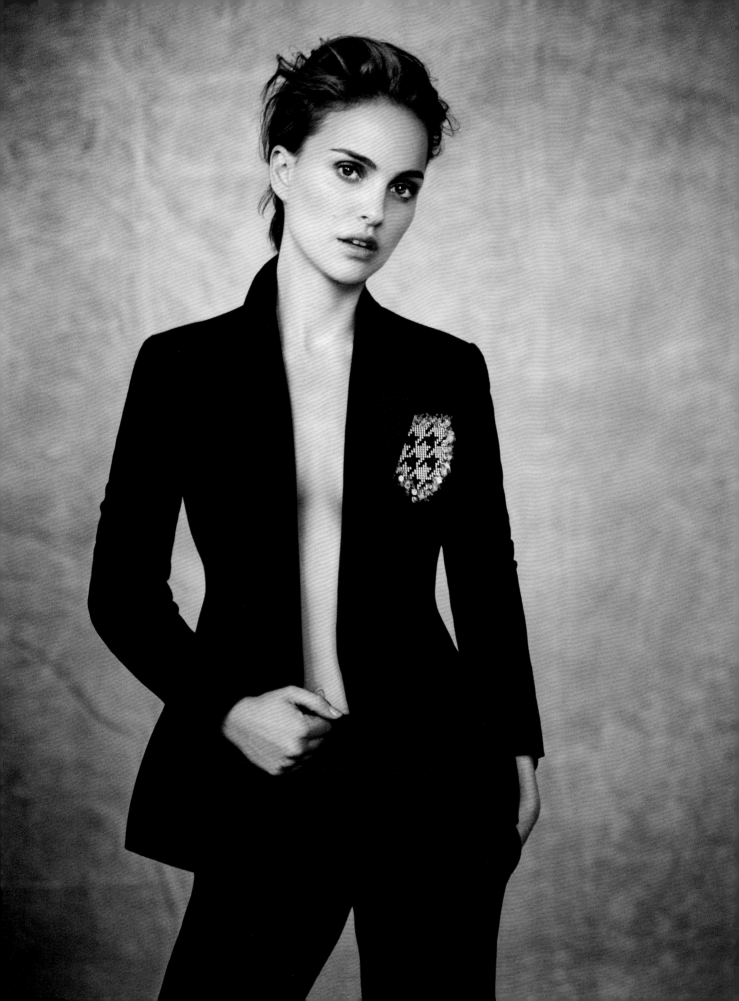

The Bar *Icon*
by Raf Simons

The *Bar* is one of the ultimate, iconic Dior looks and one of the most iconic in the history of fashion; it comes loaded with symbolism. For me it represents an entry point into the thinking of Christian Dior himself; it is an essential part of the code that is at the heart of the house, at its very foundation since his first collection. At the same time, it is part of the visual language of the mid-century; this period of time and its form of language are an obsession of mine. Just as Christian Dior was obsessed by the Belle Époque—of course, the shape of the *Bar* is a nod to that period—I am obsessed by mid-century modern! In the strictness of its tailoring and the freedom from hyper-femininity, the *Bar* silhouette is a combination I find both intriguing and attractive. It has a special significance for me, as I have spent much of my career focusing on tailoring and menswear, while at Dior I have found real freedom through the expression of the feminine—the two together are a great combination for me. I frequently return to the *Bar* to rework its elements and combine and contrast its features in different ways. For instance, in much of the clothing in the very first collection I did for Dior—the Autumn-Winter Haute Couture 2012 collection—there were many *Bar* elements, especially the focus on the curve of the hips. At the time, I wanted to define the *Bar* suit in a new way, so I contrasted the feminized tailoring of the jacket, with its curved construction over the hips, against black cigarette pants as opposed to a full skirt. I wanted it to be a new take on the tuxedo and very directly bring the feminine and the masculine together. I think great design will always have a timeless quality to it; great design will ultimately be valid in any year or era. It is the quality of the *Bar's* architecture—Christian Dior was a genius architect of pattern—that makes it timeless and makes it possible for me to interpret it in a whole variety of ways in highly different collections.

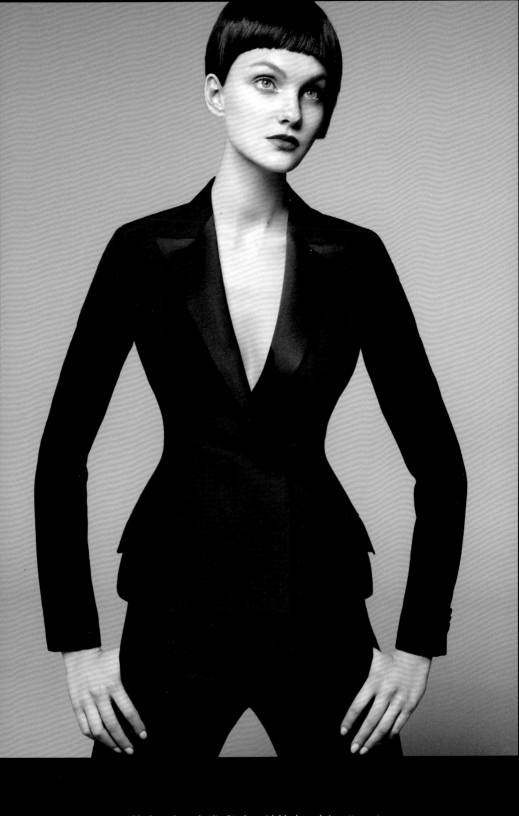

Black wool tuxedo "Bar" jacket with black wool cigarette pants,
Autumn-Winter 2012 Haute Couture collection. Photograph by David Sims.

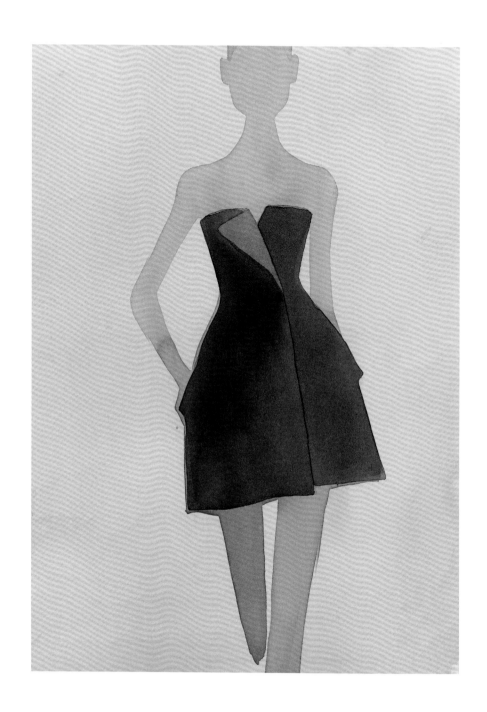

ABOVE Mats Gustafson illustration of a dress from the
Spring-Summer 2013 Prêt-à-Porter collection.

OPPOSITE Geometric "Bar" jacket in black wool and silk with silk bow detail,
silk gazar collar. Spring-Summer 2013 Prêt-à-Porter collection.
Photograph by Willy Vanderperre.

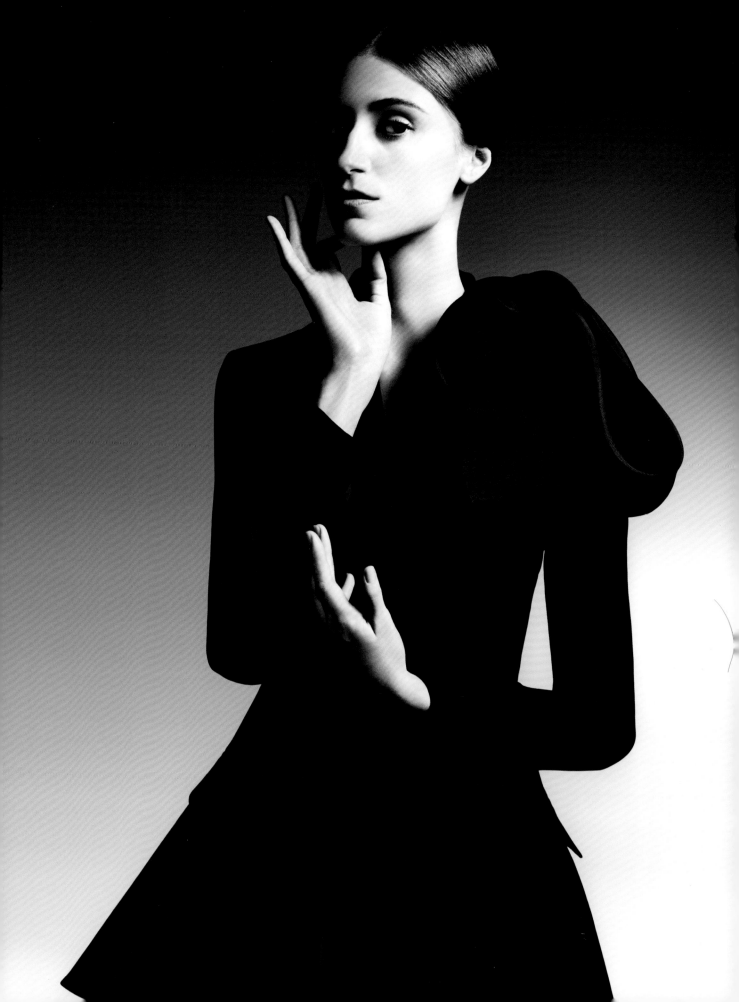

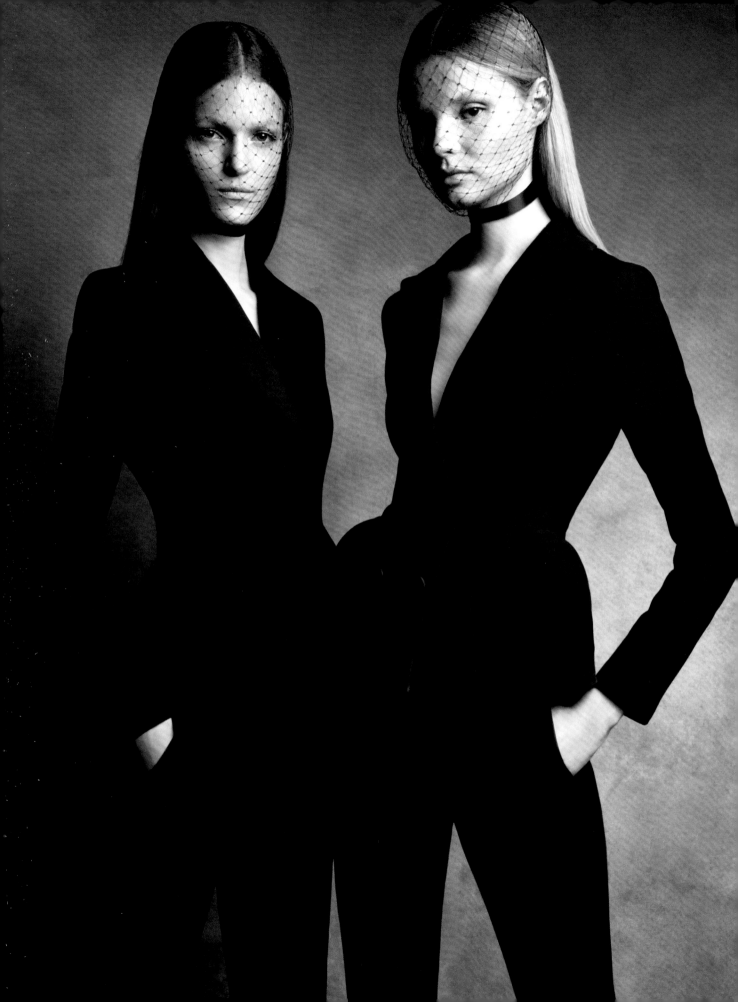

ABOVE Mats Gustafson illustration of a "Bar" tuxedo from the
Spring-Summer 2013 Prêt-à-Porter collection.

OPPOSITE Black wool tuxedo "Bar" jacket with black wool cigarette pants; black wool
double-breasted tuxedo jacket with black wool cigarette pants, Autumn-Winter 2012
Haute Couture collection. Photograph by Patrick Demarchelier.

131

Jennifer Lawrence wearing a navy blue denim wool "Bar" suit,
Autumn-Winter 2013 Prêt-à-Porter collection. Photograph by Mikael Jansson.

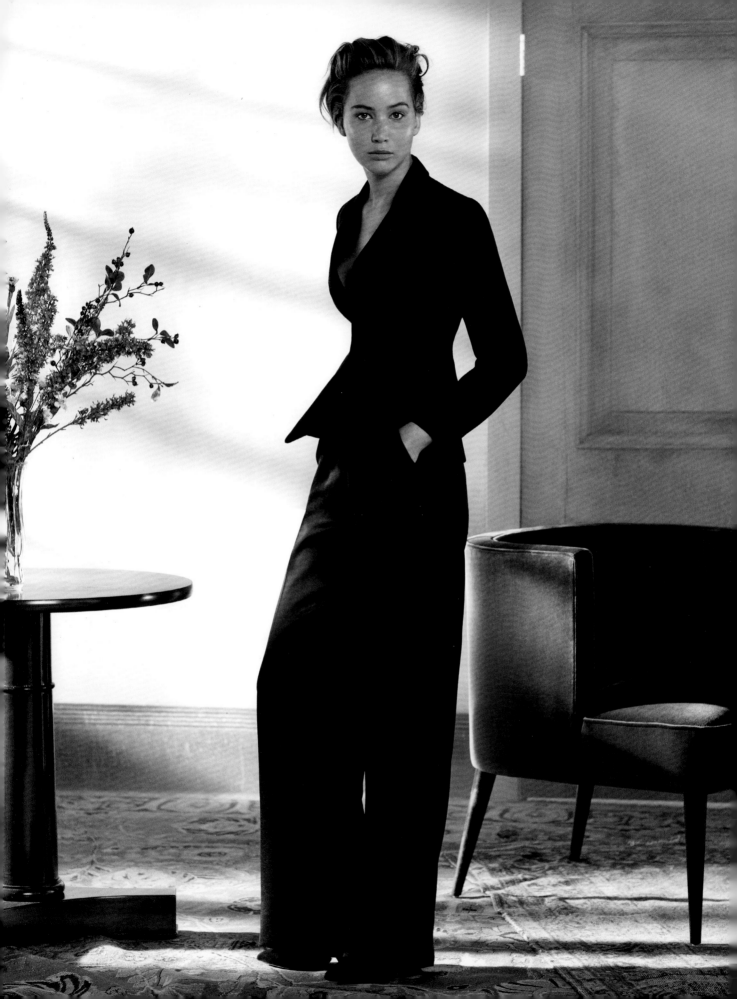

ABOVE Mats Gustafson illustration of a suit from the
Spring-Summer 2014 Haute Couture collection.

OPPOSITE Embroidered dark ink blue wool "Bar" jacket,
Spring-Summer 2014 Haute Couture collection.

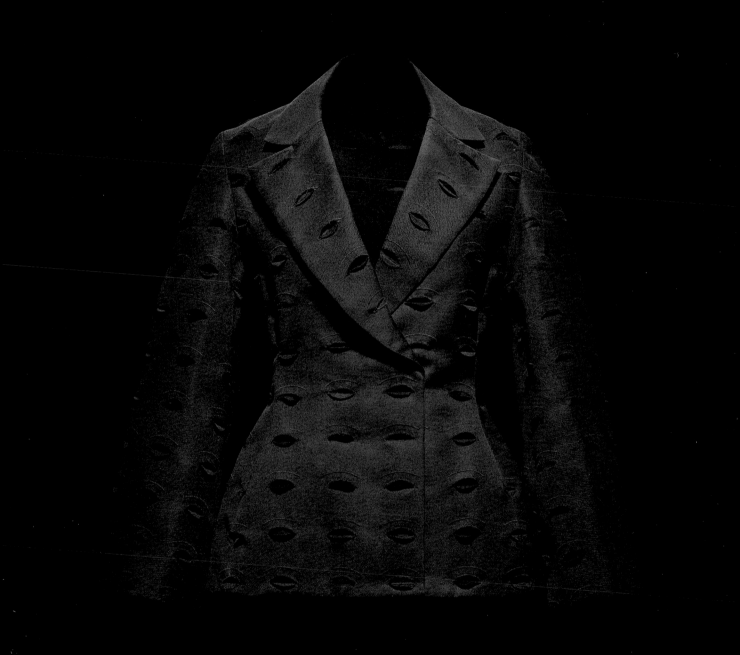

Black wool crepe "Bar" evening coat, Autumn-Winter 2012
Haute Couture collection. Photograph by Willy Vanderperre.

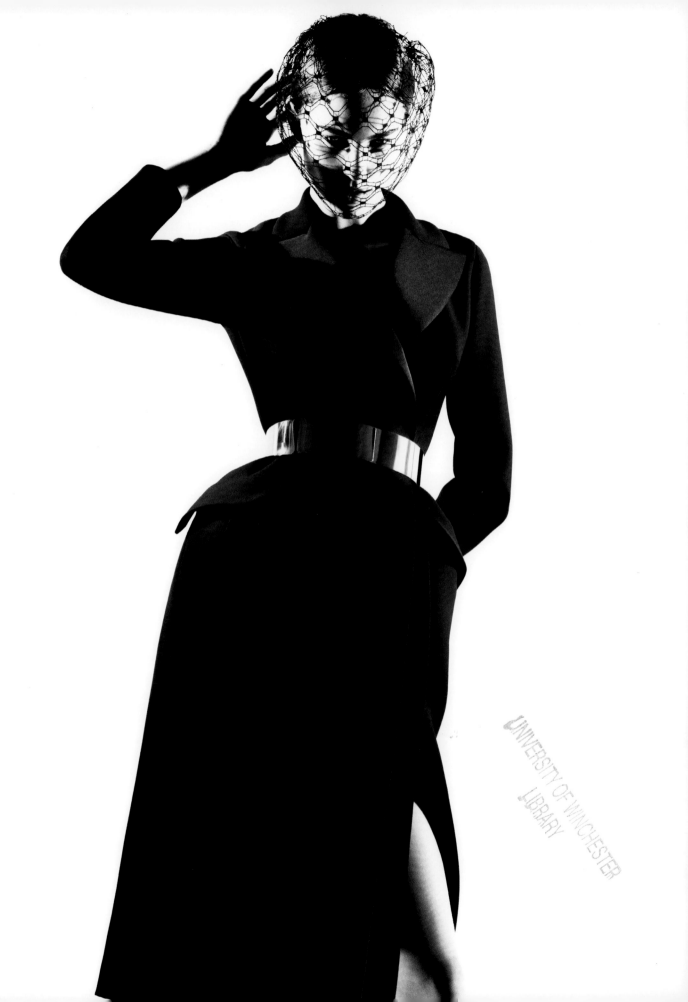

ABOVE AND OPPOSITE "Dior Red" cashmere "Bar" coat,
Autumn-Winter 2012 Haute Couture collection.

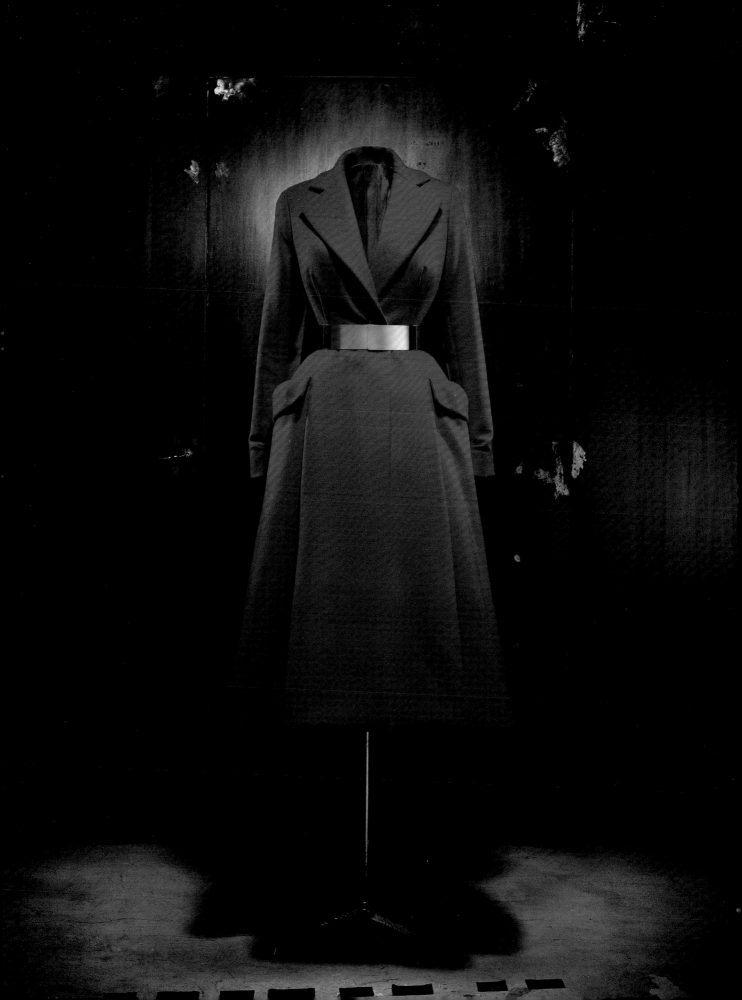

Multicolored mesh layered jacket and skirt,
Autumn-Winter 2012 Haute Couture collection.

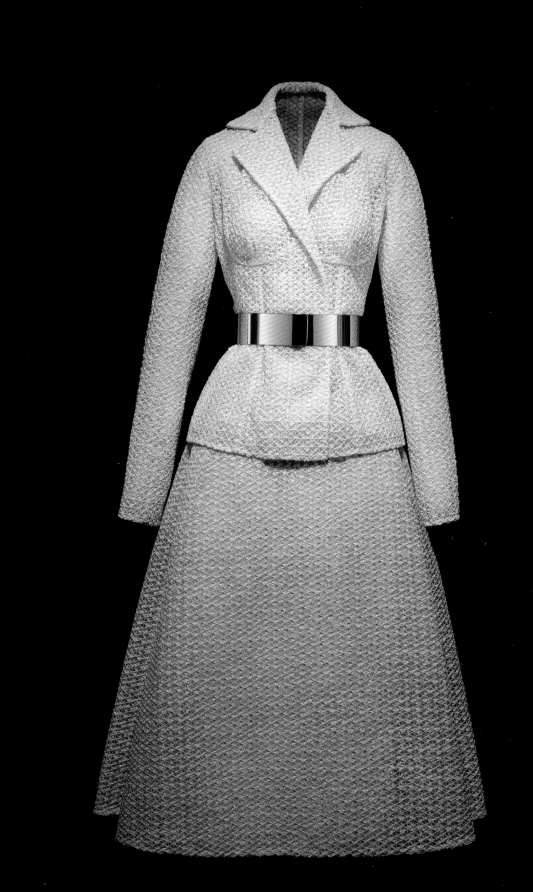

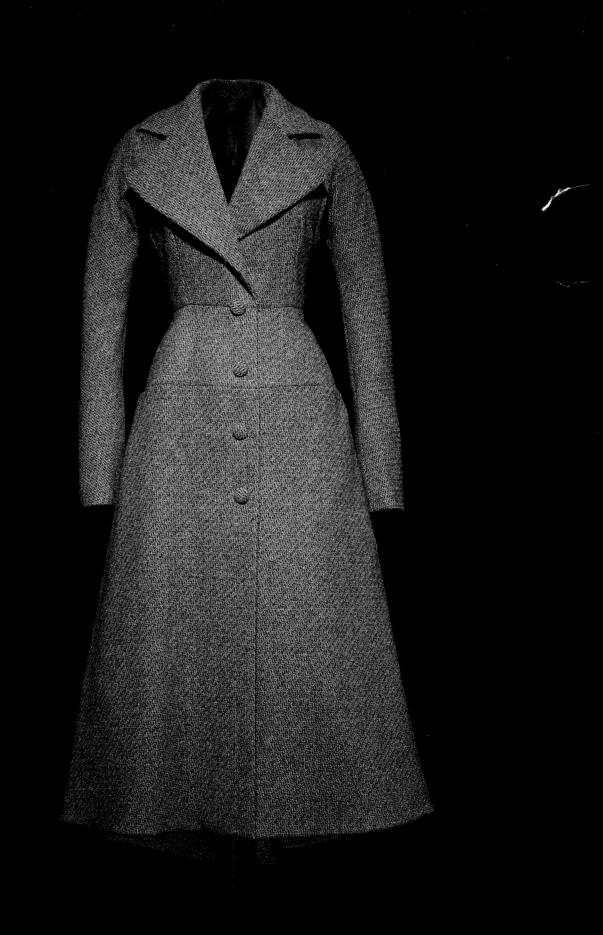

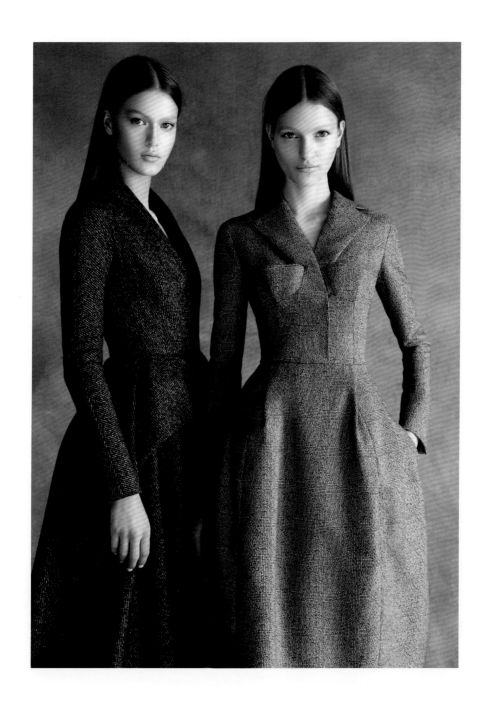

ABOVE Anthracite tweed "Bar" coat and gray Prince of Wales checked wool jacket and skirt, Autumn-Winter 2012 Haute Couture collection. Photograph by Patrick Demarchelier.

OPPOSITE Gray wool tweed "Bar" coat, Autumn-Winter 2012 Haute Couture collection.

FOLLOWING PAGES Designs from the Autumn-Winter 2012 Haute Couture collection. Photograph by Patrick Demarchelier.

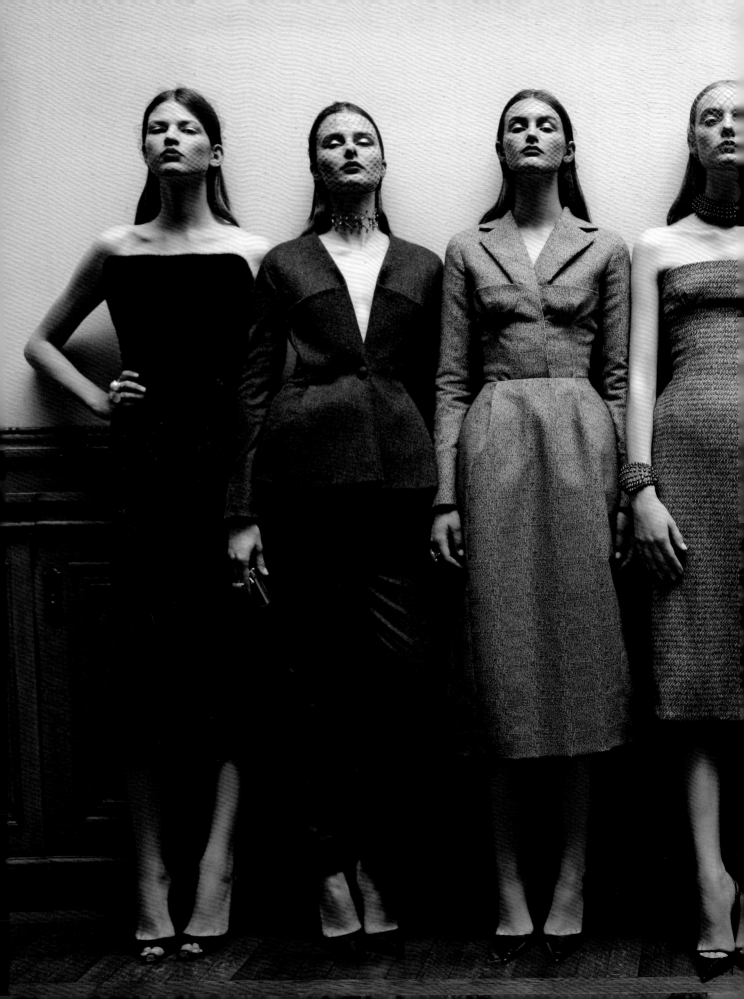

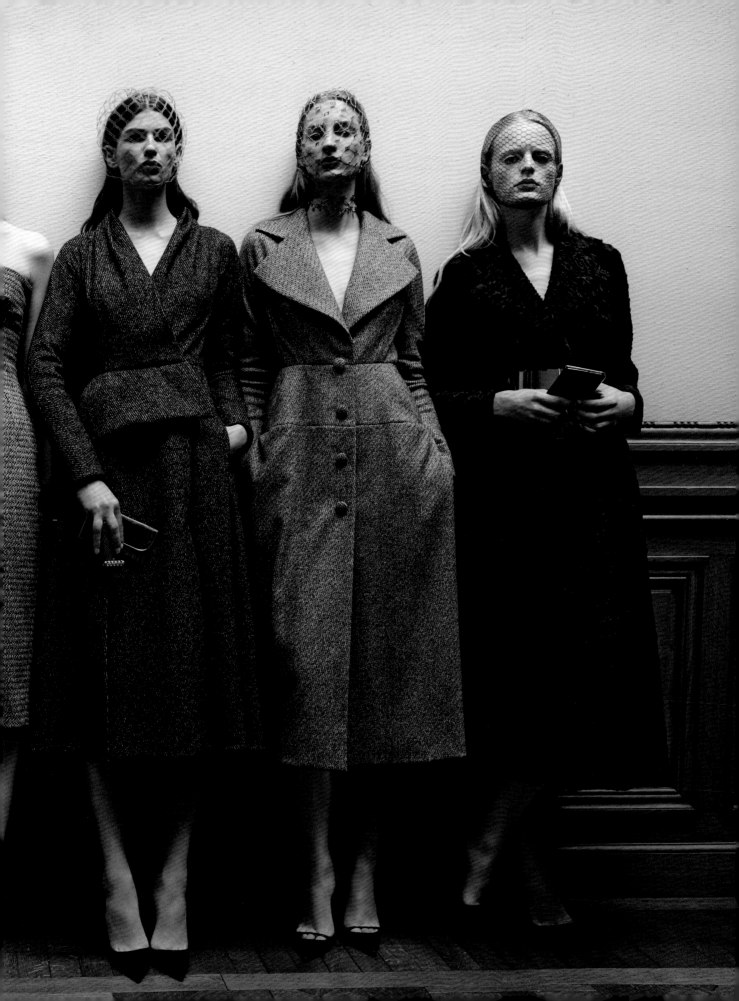

December 16, 1946: The house of Dior opens in a townhouse at 30 avenue Montaigne.

90: The number of house of Dior employees at the time.

February 12, 1947: The first collection, Spring-Summer 1947 Haute Couture, is presented. Two lines, the *Corolle* and the *En 8*, give rise to the "New Look" phrase coined by Carmel Snow, editor-in-chief of *Harper's Bazaar*. Tania, the very first model hired by Christian Dior, wears the *Bar* suit in the opening show. The New Look unleashes a passionate reaction, and the "Little Below the Knee Club" movement is born in the United States to protest the skirt length. The same year, Christian Dior's first perfume, *Miss Dior*, is launched.

4 yards: The length of silk shantung required to make the *Bar* suit jacket.

October 28, 1948: Creation of the Christian Dior New York, Inc. subsidiary company.

August 3, 1955: Christian Dior gives a lecture on "The Aesthetics of Fashion" at the Sorbonne amphitheater in Paris in front of 4,000 students. That day, the *Bar* suit takes pride of place, and is presented with other designs from the Autumn-Winter 1955 Dior collection. Restyled, and worn by the model Renée, it is photographed by Willy Maywald on the banks of the Seine. The photo becomes an icon.

March 4, 1957: Christian Dior appears on the cover of *Time* magazine.

April 1957: To celebrate the second anniversary of the house of Dior, shows are organized at I. Magnin department stores in San Francisco and Los Angeles. The designs from the latest Christian Dior collection are shown along with a selection of emblematic designs, including the *Bar* suit.

October 24, 1957: Christian Dior dies in Montecatini, Italy. Yves Mathieu-Saint-Laurent takes the helm. The house produces 50 percent of all French haute couture exports.

January 1987: Celebrations for the fortieth anniversary of the house of Dior and the New Look are held, with a retrospective exhibition organized by the Musée des Arts de la Mode in Paris. Marc Bohan, artistic director of the house of Dior since the end of 1960, creates an exact copy of the *Bar* suit for the Spring-Summer 1987 Haute Couture collection.

January 1995: Gianfranco Ferré, artistic director of the house of Dior since 1989, pays tribute to the *Bar* suit in the Spring-Summer 1995 Haute Couture collection. The *Bar* influence is also seen in the 1996 Prêt-à-Porter collection.

January 20, 1997: John Galliano, newly appointed as artistic director to the house of Dior, presents his first collection, Spring-Summer 1997 Haute Couture, in which the *Diosera* design pays tribute to the *Bar* suit.

June 30, 2008: John Galliano presents "Bar" belts for the Autumn-Winter 2008 Haute Couture collection.

July 2, 2012: Raf Simons, artistic director of the house of Dior since April 2012, presents his first collection, Autumn-Winter 2012 Haute Couture. The collection is clearly influenced by the New Look, with the *Bar* jacket reflected in the shape of coats and dresses, and paired with pants for the first time ever.

436,000: The number of Google search results related to the *Bar* suit.

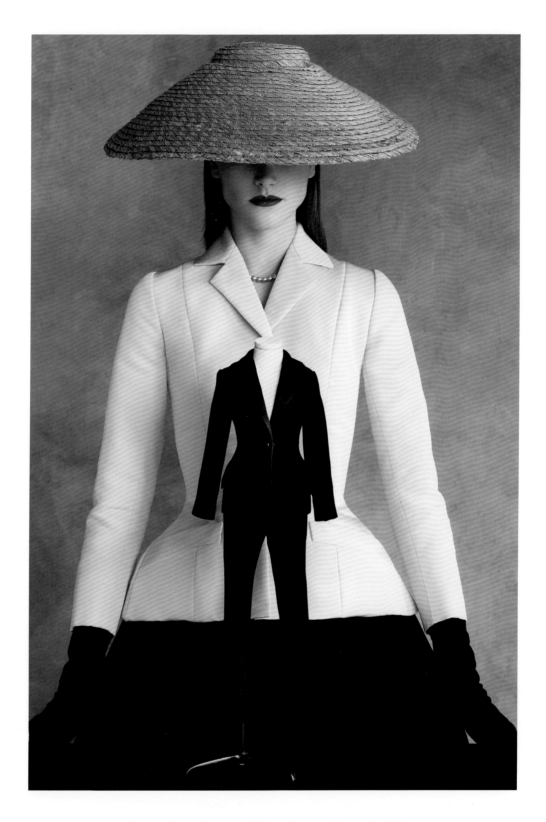

Bar suit, Spring-Summer 1947 Haute Couture collection, *Corolle* line,
and miniature of a black wool tuxedo "Bar" jacket with black wool cigarette pants,
Autumn-Winter 2012 Haute Couture collection.
Photograph by Patrick Demarchelier.

ACKNOWLEDGMENTS

This publication accompanies the exhibition *Dior: The New Look Revolution*, organized by the Présence de Christian Dior association at the Musée Christian Dior in Granville from June 6 to November 1, 2015.

This project was made possible with the support of
Bernard Arnault, President of LVMH / Moët Hennessy • Louis Vuitton,
Sidney Toledano, President Chief Executive Officer Christian Dior Couture,
Claude Martinez, President & CEO Christian Dior Parfums.

President of the Présence de Christian Dior association
Jean-Paul Claverie

General Curator
Florence Müller

Scenography
Simon Jaffrot, Noémie Bourgeois,
assisted by Marie Docquiert and Matilde Peterlini

Musée Christian Dior in Granville
Brigitte Richart, curator,
Barbara Jeauffroy-Mairet, associate curator,
Marie-Pierre Osmont, Paule Gilles,
Ophélie Verstavel, and Laura Hamonic

Christian Dior Couture
Olivier Bialobos, Solène Auréal,
Camille Bidouze, Séverine Breton, Sylvain Carré,
Cécile Chamouard-Aykanat, Gérald Chevalier, Jérôme Gautier,
Justine Lasgi, Philippe Le Moult, Anne-Charlotte Mercier,
Mathilde Meyer, Soizic Pfaff, Hélène Poirier,
Perrine Scherrer, and Hélène Starkman

Parfums Christian Dior
Jérôme Pulis, Frédéric Bourdelier,
and Vincent Leret

LVMH / Moët Hennessy • Louis Vuitton
Loïc Bégard

ACKNOWLEDGMENTS

The exhibition has been supported by:
The City of Granville,
in particular the Mayor, Dominique Baudry;
the Deputy Mayor in charge of Culture and Women's Rights, Mireille Deniau;
Virginie Frouin, Director of the Tourist and Communication Office.
Ministère de la Culture, DRAC Basse-Normandie
Conseil général de la Manche
Conseil régional de Basse-Normandie
LVMH / Moët Hennessy • Louis Vuitton
Christian Dior Couture and Parfums Christian Dior

We would like to thank the institutions
that loaned their works for the exhibition:
Palais Galliera – City of Paris Museum of Fashion,
in particular Olivier Saillard,
Sophie Grossiord, Sylvie Roy,
Corinne Dom, and Alexandre Samson.
Musée des Arts décoratifs,
in particular Olivier Gabet,
Marie-Sophie Carron de la Carrière,
Pamela Golbin, Éric Pujalet-Plaà,
Joséphine Pellas, Emmanuelle Garcin,
Marie-Pierre Ribere, and Myriam Tessier.

Private Collections:
Maison Anouschka;
Cofrad, in particular
Stéphanie and Marc Lacroix;
Béatrice Colle Saalburg;
Mats Gustafson; Nancy Li.

Many thanks to Miles Aldridge, Pol Baril,
Sophie Carre, Patrick Demarchelier, Mats Gustafson,
Laziz Hamani, Mikael Jansson, Jean-Baptiste Mondino,
Brigitte Niedermair, Paolo Roversi, David Sims,
and Willy Vanderperre.

Marion Cotillard, Jennifer Lawrence,
Natalie Portman, and Natalia Vodianova.

ACKNOWLEDGMENTS

The models Andie Arthur (IMG), Kylie Bax (Elite Paris),
Daiane Conterato (The Society), Magdalena Frackowiak (DNA),
Bette Franke (Viva Model), Ros Georgiou (The Society), Frida Gustavsson (IMG),
Tess Hellfeuer (New York Model), Jac Jagaciak (IMG), Valery Kaufman (The Society),
Hanne Gaby Odiele (IMG), Sasha Gold (Next), Sui He (New York Model),
Carmen Kass (Women), Magdalena Langrova (Elite),
Emilia Nawarecka (Next), Nicole Pollard (The Lions), Kinga Rajzack (IMG),
Anna Selezneva (Women), Katia Selinger (Next),
Olga Sherer (New York Model), Nimue Smit (Next),
Daria Strokous (Women), Melissa Tammerijn (Next),
Caroline Trentini (The Society), Vasilisa Pavlova (Supreme),
and Danielle Zinaich (IMG).

We also thank all those whose help has been so invaluable
in preparing, creating, and promoting the
Dior: The New Look Revolution *exhibition and catalogue:*
Philippe Brutus and Ian Bauman (Art+Commerce),
Raphaëlle Cartier (ADAGP), Julien de Passorio Peyssard (Getty Images),
Nelly Dhoutaut and Yasmina Guerfi (Hachette Filipacchi Associés),
Magali Galtier (Gamma Rapho), François George (Picto),
Nicolas Guérin, Romuald Habert (Digitline),
Erin Harris and Cameron Sterling (The Richard Avedon Foundation),
Nathalie Ifrah (Les Éditions Jalou), Kimberly La Porte (Art+Commerce),
Sophie Malexis, Maître Stéphane Martin, Julien Mellone (Corbis),
Felix Mondino (Iconoclast Image), Leigh Montville, Lindsay Foster
and Paul Quitoriano (Condé Nast), Jutta Niemann (Association Willy Maywald),
Isabelle Papin Petitjean (Julian Meijer Associés), Remo Pittiglio (La Collection),
Karine Quadriga, Frieder Roth, Charlotte Selignan (Art+Commerce),
Leslie Simitch and Billy Vong (Trunk Archive),
Gregory Spencer (Art Partner), Zoubida Zerkane (BnF).

Very special thanks to Pierre Cardin and Hubert de Givenchy,
and to Monique Bailly and Laurence Morel at the Tailoring atelier
for their valuable contributions, and also to Jean-Pascal Hesse.

PHOTOGRAPH CREDITS

Outfits designed by Christian Dior (1947–1957):
pages 6, 11, 13, 18, 23, 25, 27, 29, 31, 34–37, 39, 41–45, 51, 53–54, 60, 63–65, 87–88, 91, 97, 147.
Christian Dior outfits designed by Gianfranco Ferré (1989–1996):
pages 110–111.
Christian Dior outfits designed by John Galliano (1997–2011):
pages 92, 98–107, 109, 113–119.
Christian Dior outfits designed by Raf Simons (since 2012):
pages 9, 69, 70–71, 73–83, 85, 95, 121–125, 127–131, 133–135, 137–139, 141–145, 147.

Dior: The New Look Revolution
© 2015 Rizzoli International Publications, Inc.
300 Park Avenue South, New York, NY 10010
www.rizzoliusa.com

© 2015 Christian Dior

Texts: Laurence Benaïm
Foreword: Florence Müller

Archive Photography: Laziz Hamani,
assisted by Nicolas Guérin

Cover : The *Bar* suit, by Mats Gustafson

Publisher: Charles Miers
Editorial Direction: Catherine Bonifassi
Art Direction: Daniel Baer
Production Director: Maria Pia Gramaglia
Editor: Daniel Melamud

Editorial Coordination:
CASSI EDITION, Vanessa Blondel, Emma Sroussi

Library of Congress Control Number: 2015937238
ISBN: 978-0-8478-4664-1
2015 2016 2017 2018 / 10 9 8 7 6 5 4 3 2 1
Printed in Italy